Contemporary Paintings
of Malaysia

This catalogue was produced by the National Art Gallery, Kuala Lumpur, Malaysia for the exhibition '**Contemporary Paintings of Malaysia**' held at the Pacific Asia Museum in Pasadena, California from June 22, 1988 to January 22, 1989.

First Edition

Copyright © 1988 National Art Gallery Kuala Lumpur.

ISBN 983-9572-00-8

Photography by Sport Ad
Colour Separations by Far East Offset & Engraving Sdn Bhd
Catalogue Design by Sharifah Fatimah Zubir
Printed in Kuala Lumpur by Micom Sdn Bhd

Introduction

THE STAFF AND TRUSTEES of the Pacific Asia Museum are pleased to present, for the first time in the United States, paintings by 41 of the leading artists of Malaysia in the hope that these fine artists will reach a wider audience beyond their own nation.

Peninsular Malaysia has an extraordinarily rich history. Many nations have fought to control its strategic waterways and port cities. Malacca, one of Malaysia's first major cities, founded in 1511, has been home to the Chinese, the Portuguese, the Dutch, the English, and the Indians, as well as to the indigenous peoples. It is perhaps the most famous of the early cities in Malaysia, and the arts produced in Malacca reflect its multicultural history.

At the other end of the peninsula, the city of Penang (which was called Georgetown by the English settlers) is a mixture of Thai, Chinese, Indian, English, and traditional Malaysian cultures. Its dramatic landscape and diverse cultural life have influenced generations of artists and artisans.

Kuala Lumpur, not only the modern political capital but also the artistic capital as well, is one of the most stunning cities in Asia. Its fine architecture and mild climate make it one of the most attractive cities in which to live.

The contemporary art movement in Malaysia began about 35 years ago. It is quite surprising how many fine artists have emerged in such a short time. The contemporary artists of Malaysia represent a wide range of styles and techniques in painting. Many studied in either the United States or Europe, and their works reflect their early interest in the Western contemporary masters. The paintings of the artists who studied in Malaysia have a unique local flavor which will be easily recognized, drawing inspiration from the flora and fauna of the peninsula as well as its tropical light and proximity to the sea.

In 1985 Caroline Leonetti Ahmanson, who was visiting Malaysia as a member of a delegation from the Los Angeles Chamber of Commerce, was so impressed with the collection of paintings in the National Art Gallery that she asked me to visit Malaysia to arrange an exhibition. Mr. Craig Stromme of the American Embassy was good enough to arrange my visit in 1986. Since that time, I have been to Malaysia on several occasions and have met many of the foremost contemporary artists.

It has been a pleasure to work with the staff of the National Art Gallery on this important project. I have asked the director of the Gallery, Syed Ahmad Jamal, to write the body of this catalogue because of his long association with the principals of the contemporary art movement in Malaysia and because of his acknowledged expertise in this area.

The works now on exhibition are from the collections of the National Art Gallery, the University of Science Malaysia, Penang, individual collectors, and the artists themselves.

Malaysia is emerging as one of the most important nations in Southeast Asia. It is hoped that through this exhibition the American public will learn more about the strong cultural identity and artistic promise of this young nation.

DAVID KAMANSKY
Director
Pacific Asia Museum

Acknowledgements

THERE ARE MANY PEOPLE I should like to thank for their hard work and enthusiasm, working with me to organize this exhibition, "Contemporary Paintings from Malaysia".

This project could not have been completed without the enthusiastic support of Syed Ahmad Jamal, Director of the National Art Gallery, and his very able staff. Sharifah Fatimah Zubir and Wairah Marzuki were of particular help to me, and I wish to thank them for taking the time out of their regular work at the National Art Gallery to work on this exhibition.

Datuk Syed Kechik, Chairman of Program and Purchasing Committee of the Board of Trustees of the National Art Gallery has been an enthusiastic supporter since the inception of this project, and has been a gracious host to me on my trips to Malaysia. Other Trustees who have been helpful are Dato' Azman Hashim and the former Ambassador to the United Nations Puan P.G. Lim.

Many of the artists represented in the exhibition have become friends, and I wish to express my appreciation to all of them for their unstinting cooperation. The Ministry of Culture and Tourism Malaysia and the Malaysia Airlines have been generous in aiding this project, and I wish to thank the Honorable Minister Datuk Sabbaruddin Chik and the Director of Malaysia Airlines, Dato' Haji Abdul Aziz Abdul Rahman for their strong support.

Lastly, I want to thank Caroline Leonetti Ahmanson, who originated this project and had the foresight to realize its importance.

DAVID KAMANSKY
Director
Pacific Asia Museum

Contemporary Malaysian Art

IN HIS ESSAY, "What is Modern Art", Houdin stated that modern art is linked with a tradition of its own choice, of universal significance, breaking with the chronological traditions generally acknowledged in art history.[1]

Although the sensuous curvilinear carved reliefs on the "Sword" and "Rudder" menhirs in Negeri Sembilan, and the sensual plasticity of the "Jalong Bronze" can certainly be regarded as spiritual ancestors, Malaysian art today cannot claim to have direct continuity with ancient masterworks. Very few artists were aware of any inherited images for reference as historical stepping stones.

Contemporary Malaysian art as we know it goes back to the nineteen-thirties. The artists had no national archetypes to which to relate. Their tradition was being created then and there. Instead of looking back, they could only look around them at the works of their fellow artists for the experience of confronting actual art works. This was no period of subtlety; many of the works were crude and unsophisticated, but they were pioneering efforts that broke new ground. There certainly was the feel of a new era. The emphasis was on the present. The by-word was "Malaysian art starts now."

By the time of Merdeka (Independence) in 1957, the plastic arts had become a symbolically unifying form of expression for all Malaysians, transcending cultural barriers. The various racial groups who had lived in cultural compartments were connected by this contemporary means of expression and communication.

Art symbolized Malaysia's arrival in the contemporary age and arena, shifting from low-key provincialism to high-profile internationalism. The artist's efforts were related to the forces that were forging the nation. The new sense of responsibility and development were paralleled by the artist's commitment and involvement.

Happily, the raw brand of nationalism, which was officially sanctioned in a number of totalitarian countries, bypassed Malaysia. There was an absence of any form of directive or "guidance" from the authorities as to the acceptable art forms. This reflected the underlying philosophy of the newly independent nation. The total responsibility lay in the hands of artists and art organizers; Malaysian artist enjoyed complete freedom. The Malaysian public, for its part, feeling a sense of belonging with regard to changes in attitude and

technology, readily accepted the new forms of painting. By the time the momentum was reaching the ultimate goal of independence, contemporary aesthetics had become the universal norm. The form and idiom were contemporary and international, yet the spirit was national. Art became a force *in* society, not *of* society in Malaysia, due in no small part to the role artists played during the various stages from pre-Merdeka to the present.

Malaysian art "history" has been compressed within the last thirty years to produce a tradition which in other cultures has taken a long time. By the beginning of the fifties, Malaysia already had a few established and committed artists — Abdullah Ariff, Yong Mun Sen, Chuah Thean Teng, Cheong Soo Pieng, and Khaw Sia, among others, but they were almost unknown in the context of the national art circles. The Malay literati were aware of Tun Sri Lanang, Abdullah Munshi, Za'aba, Syed Sheikh Al Hady, and their masterworks. But in contemporary art there was a vacuum: there were no national figures. Exhibitions were rare, and hardly anyone bought works of art.

The fifties were pioneering years for artists in Malaysia. In the early years of the decade, a few personalities dominated the Malaysian art scene. Yong Mun Sen was one, with uncomplicated landscapes that were executed in fluid, full-flooded washes. His scenes were soft, abbreviated, sun-filled statements of form and space. They were simple in approach and direct in execution with the sheer joy of handling the medium. The views were ordinary; the ubiquitous palms and kampung scenes. Mun Sen did some highly accomplished oil paintings, as well, in a more resolved manner than in his water colors.

Abdullah Ariff's works by comparison were more involved technically with a certain level of consciousness, such as in "Bumi Bahagia" (The Happy Land). The more elaborate technique employed by him did not attract followers. On the other hand, the Mun Sen school of water color painting seemed to be "de rigeur" all over the peninsula. In one art exhibition in the late forties during the British Military Administration, the walls were crowded with works of the "School of the disjointed coconut trunks." These techniques were slavishly echoed in the works of minor artists throughout the country.

Cheong Soo-Pieng in Singapore and Chuah Thean Teng in Pulau Pinang both had received formal art education in China. Their academic training was evident in their handling of form in the sense of plasticity, especially in the figures (which were avoided by the rest), and this put them in a class with few peers. The interaction of form and space relates their works to Western contemporary tradition, while their

authority is established by mood and modulations, which are local and tropical. The influence of Picasso and the post-Cubist school are evident in their works. This is a result of their training in the art academies of Amoy and Shanghai. One thing was obvious: like latter-day Gauguins, these artists were consumed by the exotic tropics. The romance of the South Seas pervades their works.

Art groups and organizations which came into existence and grew in the fifties were instrumental in the development of Malaysian art in its early years, responding to the mounting excitement of Independence.

Peter Harris, the Art Superintendent in the Education Department, an expatriate from an art school in the United Kingdom, introduced contemporary art aesthetics and techniques to young and enthusiastic Malaysians. In 1951 he founded the Wednesday Art Group in Kuala Lumpur. A number of enthusiasts seeing a wonderful opportunity joined the group. Among them were young Cheong Laitong and Patrick Ng Kah Onn. They were later joined by Jolly Koh, Anthony Lau, Dzulkifli Buyung, Ismail Mustam, Hajeedar, Mustaffa Mahmud, and others. The group met every Wednesday and Saturday for figure drawing, composition, and sketching. Peter Harris opened the eyes of local artists. He introduced the use of gouache, a medium more plastic then the luminous water colors.

Meanwhile, in the north, Tay Hooi Keat, back from completing formal art education in the United Kingdom in 1952, introduced newly acquired concepts in art, which shocked the local art public who were acquainted mainly with the Impressionist school. Hooi Keat was fighting an uphill battle. He was appointed Art Inspector of Schools. His mission was to change the people's set views on art and to introduce new ideas in the teaching of art in schools.

Both Peter Harris and Tay Hooi Keat in the early fifties wielded strong influence on art in schools, especially on the art teachers, who formed the main group of artists in the country. These art teachers received some form of art education in the teacher-training colleges. Some underwent a one-year in-service supplementary course at the Specialist Teacher's Training Institute in Kuala Lumpur. Those who showed promise as artists were then sent for further formal art education in the United Kingdom. These artists/art educators later formed the main force of creativity in the sixties.

Leopold Ziegler has proposed that culture does not become a possibility until there is a genuine need for it.[2] This was the case with the development of art in Malaysia, which grew and developed

naturally through institutions and individuals. Art is the one natural avenue by which the various races in Malaysia can give shape to their feelings and vision. The groups that form the major components of the population are gifted in the visual arts; the ingredients are already there. Perhaps the introduction of the concept of "taking a line for a walk" in art classes was symbolically significant for art students and pupils. This innovation paved the way for a new sense of freedom in attitudes towards the teaching of art in schools and gave free reign to the imagination.

An important and influential organization was the Arts Council, formed in 1951, which played a big role in the development of art in Malaysia in the fifties and sixties. This independent body was responsible for supporting art activities such as music, drama, and the plastic arts. It was a non-profit concern, receiving an annual grant from the government. The Arts Council was the first public organization to urge the establishment of a national art gallery. In 1958, the Federation government asked the Arts Council to establish and administer the National Art Gallery. (Its administration functioned until June 1963, when the first Board of Trustees was formed.) This official recognition boosted the confidence of Malaysian artists. Their works would be collected, properly housed, presented for public exhibition, and recognized as part of the cultural heritage of the nation.

Malaysia's participation in the Southeast Asian Art Exhibition in Manila in April 1957 was an important step for artists, both in terms of recognition from the government and exposure of Malaysian art outside the country. This was the first major international art exhibition where works of Malaysian artists were exhibited along with those of other countries.

The First National Loan Exhibition held in the new National Art Gallery which opened on the 27th of August 1958, presented the state of art of Malaya one year after Independence. The influence of Cubism was strong. Among works shown was Syed Ahmad Jamal's "Anak Kembar", a figurative work which exhibits plastic relationships of form and space. Cheong Laitong was involved with problems of Cubism in "Main Gasing". Chen Wen Hsi and Chuah Thean Teng were occupied with cubistic renditions of form. Chia Yu Chian's animated plasticity and Georgette Chen's "Still Life" with gentle ambiguity were in the idiom of the Ecole de Paris. Mohammed Hoessein's portrait of "Minah" in heavy impasto was one of the most accomplished works by the artist in his career. There were Mun Sen's

watercolors in wash technique Lim Cheng Hoe's watercolors, and Khaw Sia's tranquil rendition of a riverside scene. Patrick Ng Kah Onn's deliberate effort to create a work with local roots was represented by his monumental allegorical "Spirit of Land, Water and Air" in restrained browns, proposing spiritual invocation. It is one of the major paintings of the fifties. Nik Zainal Abidin's use of the overall flatness which "extends" beyond the edge, was an important contribution to Malaysian art. However, the potentiality of this concept was not realized, and it had no significant following in its essential elements.

Tay Hooi Keat had already developed his personal style in "Fighting Bulls", showing a masterly touch of medium, means, and purpose, with a sense of exuberance which was to be one of the characteristic stamps of Malaysian painting. Peter Harris' architectonic rendition of "Venice in Trengganu", a latter-day Poussin/Turner in a minor key, showed the traits which were to influence a generation of Wednesday Art Group artists. Its deliberate, tight, structural arrangement of vertical and horizontal forms is balanced by strong curves. This basic formula beloved of post-war English Art School composition classes was a force countering the tendency to rely on the Dionysian movements of the brush. "Combing the Hair" by Lim Nan Seng is an early effort by a Malaysian sculptor to simplify and recreate tangible forms in space. Nan Seng's sculpture, greatly increased in scale, effectively created an awareness of the possibilities of sculpture as a means of space enhancement.

The first one-man show by a Malaysian artist overseas, that of Chuah Thean Teng, was presented in London 1959 by the Federation Arts Council. In the same year, the first of the "Young Friends" (the Arts Council) Art Exhibition was held. The idea of the "Young Friends" was a commendable one in forging early interest and continuity in art.

The most important single factor in art is the artist, the creator. Yet, the art scene in any country is comprised not only of artists but also patrons, art suppliers, organizers, gallery owners, critics, and others who help to create the mystique which surrounds the world of art. The art world of the fifties was already peopled by characters who entered and re-entered the worlds of reality and imagination, forming interweaving patterns in the fabric of contemporary culture. Paris of the early 20th century had its Appollinaire, Kuala Lumpur of post-Independence years had its Frank Sullivan. In those vital years, his name was like magic, conjuring possibilities and realizations in the

Malaysian art world. From his arrival in Kuala Lumpur in the late fifties, Frank — as he was affectionately known to artists and art lovers — played a crucial role in a large number of art activities, especially those of the Arts Council and the National Art Gallery. The name Frank Sullivan was closely related to the plastic arts from the late fifties to the mid seventies as collector, patron, organizer, auctioneer, and gallery owner. He was one of the first serious collectors of Malaysian art.

In the sixties, Malaysian art events were deemed worthy of newspaper headlines, pictures in the national papers, and radio and television news broadcasts. Art exhibitions were opened by government officials and attending by artists and art lovers. These gala events were considered among the major cultural activities in the country. Artists could be seen in the company of politicians and diplomats. Plastic art was considered to be one of the major forms of expression.

The morale of Malaysian artists was boosted in the 1960s. Malaysia participated in more major exhibitions overseas. These included the Fourth International Contemporary Art Exhibition held in New Delhi in 1961, the First International Art Exhibition in Saigon in 1962, Commonwealth Art Today in London in 1962-63, the Southeast Asian Cultural Festival in Singapore in 1963, the Waratah Spring Festival in Sydney in 1965, Malaysian Art Travelling Exhibition in Europe in 1965-66, the First Triennale of Contemporary World Art in New Delhi in 1969, the Tenth Biennale in Sao Paulo in 1969, and the Asian Countries in Contemporary Art in Tokyo in 1969.

The first big effort to present Malaysian art overseas was the Malaysian Art Travelling Exhibition, which consisted of more than 100 works. It was first shown in the Kelvingrove Art Gallery in Glasgow as part of the Commonwealth Arts Festival in the autumn of 1965. The exhibition received favorable comments from art critics. "The Scotsman" commented that, "the exhibition is immensely exuberant, full of a sense of well-being (and an ability on the whole, to express it adequately)".[3] Emilio Coia in the Glasgow Herald of September 1965 commented, "The surprising feature is that in a country which only became art-conscious — in the sense that it gave practical encouragement to its artists and organized outlets for their work — less than twenty years ago there would be so much evidence of technical accomplishment and assimilation of the basic aesthetics underlying recent phases and developments in modern art ... the abstractions for instance ... are possessed of a conviction and pictorial

consciousness that could easily earn them a place with the British and American abstracts in the Tate Gallery"[4] Sheldon Williams, writing in the *Paris Herald Tribune* on February 8, 1966, said of the Glasgow exhibition, "It is a brave new land that is prepared to show a gathering of its artists in an important gallery — as if such an exhibition was indicative of national talent. And, I therefore submit, with great pleasure, that this is mainly an exhibition of a high standard including some outstanding interesting contributions."[5]

"Salon Malaysia", organized by the National Art Gallery in 1968 and sponsored by the Malayan Tobacco Company, was one of the major art events of the sixties. Its competition panel was the first to include foreign judges — from Australia and Singapore. It also marked another turning point in the history of Malaysian art. This was the last of the art competitions to be based on the traditionally accepted concept of easel paintings which were compartmentalized into various categories by type (paintings, pastels, sculpture, etc.) rather than by concept. Though the excitement of participation and the necessity of winning prizes were too attractive to resist, Malaysian artists, influenced by events which were taking place in other parts of the world, had begun to question the validity of perpetuating the respected practice of easel painting.

The Merdeka artists of the fifties and sixties subscribed mainly to the aesthetics of Abstract Expressionism. The immediacy and mystical quality of the mainstream art of the 1960s appealed particularly to the Malaysian temperament, sensitivity, and cultural heritage. With the tradition of calligraphy, they found in that idiom the ideal means of expression. Malaysian artists developed a rapport with the bold gestures of Kline, Soulages, Hartung, Mathiew, Sugai, and the delicate cryptic gestures of Zou-wuki. The gestural qualities of their works have obvious affinity with the traditional art of calligraphy, which is the cultural heritage of Malays and Chinese — a visual language immediately felt and perceived by Malaysians. The influence of Jawi form in Syed Ahmad Jamal's works and the characteristics of Chinese calligraphy in Cheong Laitong's works are vivid examples.

It was important that avant-garde art was accepted, if not by the society at large, at least by those involved with the arts. Abstract Expressionism (and Action Painting), the mainstream force in the sixties, was a catharsis, a direct form of release. Abstract Expressionism was not in reality a borrowed idiom. It was a natural development from the loose atmospherics of the early watercolors of Malaysia.

The first "New Scene" exhibition was a significant art event of 1969 and appropriately gave the signal for the end of the era of gestural emphasis in Malaysian painting by introducing a new generation of artists. The "New Scene" Exhibition was intentionally committed to injecting an awareness of changes that had to take place. To counter the deeply entrenched Abstract Expressionism which had become a characteristic force in Malaysian art of the sixties, the approach of these artists was coolly based on optics and information. This change in attitude was necessary and recalled the position of artists on the eve of Independence.

Whereas the main generating force at the end of the fifties was that of the newly returning art students from Europe and the Wednesday Art Group supported by the Federation Arts Council, the New Scene combined the energy of the teaching staff of the Fine Arts Department of the MARA Institute of Technology with other artists who had a similar sense of commitment. And, whereas the Merdeka artists felt that the brush and the paint should do the talking, the New Scene artist — with the articulate Redza Piyadasa and Sulaiman Esa at the helm — advocated the necessity to verbalize their manifestations. The action of the group was a much needed catharsis in the rejuvenation of art in Malaysia. At times it is necessary to destroy a tradition in order to make possible the birth of another. The .act that the leading members of this group worked in an atmosphere of an art school proper, the first "serious" art institution in the country, helped to make this possible.

Events that took place in May 1969 stunned Malaysian artists as well as the rest of society. For a while no artists were producing any works at all. Cheong Laitong reflected, "After what happened, I don't feel like painting any more ... there is no point ..."[6] Yet the human spirit being what it is, after a while the creative force began to regenerate. Syed Ahmad Jamal did a series of drawings on the theme of events that took place on May 13th, 1969,[7] for the "Tenggara" journal and painted "One Fine Day." Ibrahim Hussein's painting of the Malaysian flag in black was a counterpart to Jasper Johns's bleached Stars and Stripes. These were necessary, compulsive documentaries. Those vitally important years were colored by excitement, exaltation, apprehension and, towards the end, a shattering shock. The state of dismay which followed was a sobering farewell to the sixties.

The sixties had given birth to a more critical approach to art. While the late sixties had produced some highly accomplished mature works

in the idiom of Abstract Expressionism, changes in direction and areas of involvement began to be apparent. Malaysian artists questioned the validity of their work in the context of Malaysian culture and in relation to the international scheme. The end of the sixties saw the artists' involvement with local materials and the local environment as ingredients of visual imagery. They entered a new era of awareness, probing into their consciousness, social environment, and cultural heritage.

To herald the seventies, Malaysia participated in two major art exhibitions that took place in 1970 — EXPO '70 in Osaka and the "Man and His World" Exposition in Montreal. Malaysia's top artists used poems by some of the leading Malaysian poets as points of departure in the "Manifestasi Dua Seni" (Manifestation of the Two Arts) exhibition. It was a deliberate effort to combine the two art forms. It generated an interest among literary and art groups, and the response that ensued brought plastic art to the attention of the literary public. The National Cultural Congress, held in Kuala Lumpur in 1971 was a major event. It was convened to advise the government in formulating its policy on national culture. In conjunction with the Congress, an exhibition of Malaysian art from 1932 to 1971 was presented. The works ranged from Abdullah Ariff's genre watercolors done in 1932 to Tan Teong Eng's clinical silver stripes of 1971.

Believing that the beginnings of contemporary Malaysian art could be identified in landscape painting, the National Art Gallery organized the "Landscape Malaysia" Competition and Exhibition in 1972. Its objectives were to revive interest in Malaysian landscape and to reconsider its meanings, not only in terms of its physical attractions but also in terms of its manifestations in past and present cultural practices in Malaysia. The Major Award winners were Redza Piyadasa's "The Great Malaysian Landscape" with historical and contemporary universal references and Lee Kian Seng's surrealistic "From the Windows of Red."

An article in The Art International of May 20, 1972 featured seven Malaysian artists and introduced the country, was of the opinion that Malaysian painters were gifted, subtle, and "difficult". The artists featured were Abdul Latiff Mohidin (represented by "Triptych" with interlocking forms), Choong Kam Kow with his semantically witty shaped canvas "S.E.A. Thru Resting 1971", Ismail Zain's "7:00 pm" in which colors of the doilies and stripes interrelate in counterpoint, Jolly Koh's dreamy abstract, "Landscape", Khalil Ibrahim's '...soft Bonnardesque glow...", Syed Ahmad Jamal's "1968", and Tan Teong Teng's hard-edge Op painting.

Another important exhibition was "Towards a Mystical Reality" in 1974, presented by Piyadasa and Sulaiman Esa. These two artists helped to maintain a healthy state of affairs in Malaysian art by presenting an exhibition which rejected traditionally accepted means of expression and the notion of art objects as commodities. Their emphasis was on experience itself in accepting the actual physicality of things, to be aware of, and perceive, objects not created by the artist. It was a conscious effort to dispel any association with the tradition of easel painting.

With the purpose of tracing the origin, development, and direction of three-dimensional plastic art, "Modern Sculpture in Malaysia" was presented in the National Art Gallery in 1976. A scholarly view on these works was propounded by Mr. Kanaga Sabapathy of Universiti Sains Malaysia. Sculpture did not have a healthy development in Malaysia. Although there exist some sculptural objects with superior aesthetic qualities — as in the group of menhirs in Pengkalan Kempas and Negeri Sembilan and the Jalong Bronze, there has been no continuity of tradition.

The seventies saw the beginning of a change in direction in Malaysian art away from the strong influence of Abstract Expressionism. Malaysian artists not only worked in the realm of Minimalism, Pop, Op, and other trends of the seventies but also began to postulate artistic situations involving perspicacity, mystical and metaphysical values, information, and knowledge traditionally outside the realm of painting.

Hard-edge painting with its emphasis on flatness and non-gesture found a strong following in Malaysia in the early seventies, especially with the teaching staff of Institut Teknologi MARA and its sphere of influence. Among the leading exponents of this particular idiom are Choong Kam Kow, Tan Teong Eng, and Tang Tuck Kan. Choong Kam Kow's "Sea Thru-Open" (1971) fuses the intrinsic qualities of painting and sculpture, while his "Sea Thru-Flow III" (1974) in plywood emphasizes art in the context of modern technology with a twist of semantics; Tang Tuck Kan juggles geometrically with his "Square No. 7" (1971).

Ismail Zain's major contribution to the seventies were his architectonic grid composition. These combined flat, soft-sprayed, veiled areas, brush strokes, and the interplay of surface and space, as in "Surface in Space No. 3" (1971). Ahmad Khalid Yusoff used the Jawi script forms as pictorial elements with symbolic cultural connotations in tightly controlled compositions, as in his "Alif Ba Ta" (1971) series.

Joseph Tan returned from the United States with his "Landscape" (1972) series, the pictorial surfaces of which have a surrealistic spatial quality. Ibrahim Hussein's "Ceh Tak Puas-Puas" (1975) chides the middle class while Chung Chen Sun's "Landscape" (1975) in Chinese ink follows the tradition of Chinese painting.

The works which represented 1976 were not markedly innovative. "1000 Vowel Sound", a lithograph by Ahmad Khalid Yusuf: "Ingatan IV" by Khalil Ibrahim; "Reclining by the Lake" by Khoo Sui-ho were simply new works in established forms. In Cheong Laitong's "Image Lost and Found" series, the calligraphic imagery was angular.

The 20th anniversary of Malaysian independence saw the exhibition, "Plastic Arts in Malaysia 1957-1977", in the National Art Gallery. It was opened without fanfare on August 30th, the eve of the National Day. The rationale was a visual survey of the development of Malaysian art from the years around Merdeka to the year 1977. Works from the sixties, the golden years of the burgeoning and efflorescence of Malaysian art, formed the major portion of the Exhibition. Twenty years after independence, Malaysian art was heading towards a bright future.

In 1978, "Malaysian Art 1965-1978", curated by Syed Ahmad Jamal, was presented at the Commonwealth Institute in London. This was the second such exhibition; the first was in 1965. The exhibits ranged from Chuah Thean Teng's idyllic "Under the Palms" (1965) with vertical emphasis countered by languid curved palms in soft pinks through the strong formal imagery of Abdul Latiff Mohidin and Dzulkifli Dahalan's acid social comments. Also included were the expressionistic gestures of Cheong Laitong, Ibrahim Hussein, Syed Ahmad Jamal, and Yeoh Jin Leng; the lyrical qualities of Jolly Koh and Joseph Tan; the accomplished sculptures of Anthony Lau; the immaculate hard-edge works of Choong Kam Kow; and the provocative mystical qualities of Piyadasa and Ruzaika. Altogether it was an impressive display of the best Malaysian art during the previous 13 years. It showed that Malaysian artists had fully assimilated international aesthetics and had created something of their own. This exhibition showed a mature state of Malaysian art.

In 1979, Redza Piyadasa, as guest curator of the National Art Gallery, presented an important exhibition, the "Nanyang Artists" Retrospective. This was a tribute to the Nanyang Academy of Fine Art, founded in 1938, and its role in the development of art in Malaysia and Singapore. On the staff of the Nanyang Academy were such major figures of the region as Cheong Soo Pieng, Chen Wen Hsi,

and Georgette Chen. Working within the Western tradition of easel painting and Eastern scroll painting, the Nanyang School set out to synthesize Eastern and Western aesthetics in a modern frame of reference. Artists of the Nanyang School deliberately included aspects of the Malaysian environment in their work as a means of injecting local flavor.

In the seventies, there was also a growing awareness of regional ties and of a common cultural heritage. Each of the countries in the region had been looking outwards to cultural ties with their former colonizers or with the major Asian cultural heritage but not with each other. The "ASEAN Mobile Exhibition" of 1974 was a collective effort to present art works of the ASEAN member countries. The exhibition was shown in Bangkok, Kuala Lumpur, Singapore, Jakarta, and Manila. For the first time, art enthusiasts in the various countries witnessed the rich range of the region's art.

All of these advancements notwithstanding, the "Art Scene" column of the *New Straits Times* of January 8, 1978, noted that in terms of creative activity, public response, and patronage, Malaysian art had been in the doldrums for the past few years. As a kind of spiritual barometer, it reflected the temper of society. The gloomy pictures of depression, inflation, and tension of the preceding years had an adverse effect on art in Malaysia. What was badly needed to revive the exhilarating spirit of the sixties was support for art in the form of constructive patronage.

In 1980, art patronage was on the increase. Esso Malaysia decided to build a collection of Malaysian art to be housed in their new building, to consist of works by established and new artists. This collection served to support and stimulate the development of art in Malaysia. In the same year, the National Electricity Board commissioned six leading artists — Abdul Latiff Mohidin, Ahmad Khalid Yusuf, Chew Teng Beng, Hoessein Enas, Redza Piyadasa, and Syed Ahmad Jamal — to produce works on the theme of "Energy" for their 1981 calendar. The calendar, hung in homes and offices, was an effective means of popularizing the works of Malaysian artists.

The Young Contemporary Competition in 1981, organized by the National Art Gallery, inspired some works with relevant social and cultural themes. They included a wide range of styles and exciting directions as well as the use of new media. Outstanding was "Chess Alibi Pulau Bidong" by Ponirin Amin, depicting the plight of the refugees with a freshness of approach and intelligent use of non-artistic media. Sharifah Fatimah's visualization of pulling and pushing

forms and space and Ruzaika Omar Bassaree's Dungun Series, "Window Within Window", became established in Malaysian imagery. Syed Shaharuddin enriched the range of batik with strong cultural references. The intent of this exhibition was to focus attention on the development of younger Malaysian artists whose daring experiments were also socially meaningful.

In 1982, the National Art Gallery marked the Silver Jubilee of Independence with a comprehensive exhibition which surveyed artistic activity in Malaysia back to the thirties. A total of 147 paintings and sculptures by 80 artists were displayed. This, the most comprehensive exhibition of Malaysian art ever assembled under one roof, gave an idea of the breadth of Malaysian art.

The year 1983 saw the flowering of art patronage. It was a tremendous year, full of vigor, change and promise. Art entrepreneurship also began to play a more positive role. The development of facilities for art presentation produced an increase in the number of exhibitions — at times as frequent as three openings in one week. The contemporary exhibitions, almost without exception, featured works by local artists, most of whom were under thirty years old. There was also a marked increase of interest in Chinese painting; many of the exhibitions featured works by artists from Hong Kong or Taiwan.

There was a new trend of sponsorship by corporations and individuals, and there also appeared a new class of art patronage by young professionals. An interesting point to note is that in the early 1980s newcomers to the art scene were willing to pay comparatively high prices for works by young artists. Art prices in general rose to five times those of the late seventies. An artist's reputation did not necessarily guarantee a market. The new collectors were not influenced by established names but relied more on artistic intuition and their own experience and perception. These collectors seemed to identify themselves with works by artists of their own age group.

The presentation of art works also became more sophisticated. Although only one new gallery opened in 1983, facilities at hotels, foreign legations, and cultural centers helped to develop a healthy state of art in Kuala Lumpur. Attendance and sales at exhibition openings were encouraging in spite of a general, world-wide economic recession.

The publication of "Modern Artists of Malaysia" by Kanaga Sabapathy and Redza Piyadasa in 1983 was a serious effort to document current Malaysian art, although the book met with mixed response from the public.

The announcement in 1983 that the government would lease the historic Hotel Majestic building to the National Art Gallery for its new premises met with opposition from the newly-formed Malaysian Heritage group, which wanted the building to be retained as a hotel. As a gazetted building with historical and architectural values, it could not be used as a hotel but could be used for non-profit purposes. A few other institutions were also interested in the building, but the government considered the Gallery's case to be the most valid. The National Art Gallery's stand was that it needed larger premises after being in existence for 25 years and that the Hotel Majestic building, ten times larger than the premises the National Collection occupied at that time, would be suitable to display it. There would be few physical changes. The building would serve the society at large rather than a small number of hotel guests. As the custodian of art, the National Art Gallery would be capable of preserving the building, thus saving it from an increasing state of neglect. In the end, art won the day with the support of the Ministry of Culture, Youth, and Sports. And so 1983 ended on a happy note for art.

As part of the Islamic Civilization Exhibition in May of 1984, the National Art Gallery presented an international exhibition in which Bangladesh, Indonesia, Lebanon, Malaysia, and Turkey were represented by works of some of their leading contemporary Muslim artists.

In January of 1985, the permanent collection of the National Art Gallery was put on display on three floors of the Gallery. For the first time, the public could view the collection, which until then had been in storage in cramped quarters. This was combined with the opening of the "Open Show", making a double celebration. Part of the "Open Show" was taken to the states of Sabah and Sarawak to give the public in East Malaysia an opportunity to view current works by Malaysian artists. This was made possible with the sponsorship of Shell Companies in Malaysia.

July of 1985 saw the inauguration of the Kuala Lumpur Arts Festival, the first event of its kind of Malaysia. The visual art section was composed of an invitational exhibition by Jose Joya from the Philippines, Printmaking from Thailand, and Fabric Art from Malaysia.

The National Art Gallery and the Malayan Nature Society, with the cooperation of the *Star* newspaper, Cheq-Point Credit Card, and the Malaysian Railway, organized a visit by a number of Malaysian artists to the Endau-Rompin forest reserve, which turned out to be one

of the most significant events in the development of Malaysian art. In August and September of 1985, 20 artists spent 5 or 6 days in small groups, experiencing the natural environment of the forest reserve that lies inland between the states of Johore and Pahang in the eastern part of the central Malaysian peninsula. The days and nights spent in exploring the jungle — wading the streams, scaling Janing Barat hill with its highland swamp, giant palms, strange vegetation, and rock formations — proved to be a great inspiration to the artists. An exhibition then was held in November-December of that year in the National Art Gallery. Fifty percent of the proceeds from sales were donated to the Malaysian Heritage and Scientific Expedition.

The Endau-Rompin experience was a catalyst for Malaysian artists much as the romantic Fontainebleau Forest with its luxuriant vegetation and strange rock formations was an inspiration for the Barbizon artists (Millet, Rousseau and others) of 18th and 19th century France.

In 1986, the National Art Gallery presented the Retrospective Exhibition of the works of Ibrahim Hussein, one of Malaysia's leading artists. The exhibition displayed the range and stature of his development from the greys and textural patterns of the sixties through the monumentality of the octopus offerings, the impact-making socio-political visual statements of the seventies, to the sensuous linearity of his current works.

Of more than ordinary interest that same year was the "Side By Side" exhibition which presented 63 works by 23 British artists and 55 works by 28 Malaysian artists, held to coincide with the meeting of the Malaysian British Society. The British side was represented by some of the leading names in the British art world — Peter Blake, Patrick Caulfiel , Richard Hamilton, Patrick Heron, David Hockney, Allen Jones, and Bridget Riley. The Malaysian side was represented by artists who had undergone formal art training in Britain. They included most of the leading artists in the country, such as Ahmad Khalid Yusof, Cheong Laitong, Ibrahim Hussein, Ismail Zain, Syed Ahmad Jamal, Redza Piyadasa, Sharifah Fatimah Zubir, Sulaiman Esa and Yeoh Jin Leng. This exhibition provided an opportunity for artists and the public to compare the works of the Malaysian artists and their British counterparts, some of whom were their former tutors. There was excitement among the public when works by Nirmala Shanmughalingam were taken down by sponsors, who were of the opinion that the works offended the sensibilities of the British guests, and impeded the healing process in the once-strained British-Malaysian relationship.

In March of 1986, the National Art Gallery drew the attention of 'one of the local newspapers when it reported that some works from the permanent collection of the Gallery were pornographic in nature and therefore not suitable to be displayed to the public.[8] The Gallery's position was defended in the Parliament as it debated issues of what is "pornographic", "erotic", "sensual", and "suggestive".

Art patronage was still comparatively healthy in 1986. The National Bank acquired paintings for its new headquarters in Kuala Lumpur. The United Malayan Banking Corporation donated to the city a ten-meter-high public sculpture by Syed Ahmad Jamal. There were also a number of commissions for public and private buildings.

And 1987? Thirty years after Merdeka. The Open Exhibition of the National Art Gallery held in February with the theme of Merdeka (Freedom) received some comments in the local press to the effect that many of the works missed the point of the theme.[9] Another important exhibition was the Tasek Chini exhibition held in May by the Malaysian Artists' Association as a creative response to the artists' visit to the legendary lake in Pahang, an organized artist's expedition to a natural site — the first having been their trip to Endau-Rompin.

The eighties have been years of reassessment. There has been a strong change of direction toward Eastern values, especially in economics and industry. Malaysian artists have turned away from complete reliance on the West for the latest move in avant garde art. They are no more to be terrorized by not being with the latest in universal contemporary art. (In his essay, "The Terrorist Aesthete", Alberto Moravia commented that avant garde is terrorist because it believes not in values but in time, that anything which is not in time is obsolete.)[10]

In Malaysia, the one dominating force has been Islamic fundamentalism. Among a number of Malay (Muslim) artists, Islamic principles have come to be central to their artistic commitment. In Islamic art, nature is de-emphasized, drawing the viewer to the notion of divine transcendence. Influenced by established Muslim artists such as Sulaiman Esa and Ahmad Khalid Yusuf, the younger generation of artists are fundamentally committed to Islam. They represent youth's search for inner peace, for a higher plane of values. In May 1984, the Islamic Civilization Exhibition was an attempt to give shape to the notion of pictorial art created within the framework of Islamic ideological principles. In a seminar which followed the exhibition, it was noted that in a pluralistic society Islamic aesthetic principles could be adopted by non-Muslims in the same way that Christian and Zen

Buddhist principles had influenced the works of Muslim artists. One learns from history the influence of Islamic art on the works of Henri Matisse, and Paul Klee.[11]

Since the late seventies, there has been some awareness of the social role of the artist. Among those active in sociopolitical protest is Nirmala Shanmughalingam, who paraphrases photojournalism into the dialectics of art. Another dedicated artist is Ponirin Amin, who painted "Chess Alibi at Pulau Bidung" (1981), a witty postulation. Awang Damit pinpoints the struggle in Lebanon with the etching, "Post-Card to the World" (1978).

Malaysian art has come of age. The first generation of artists are already in their sixties or older. They were either self-taught or trained in China. The next generation, the first local-born artists to be trained overseas (at first in the United Kingdom and later in the United States), are in their fifties; they are either full time professionals (a small number) or hold senior posts in art schools and universities. They represent the main force in Malaysian art.

The second half of the eighties finds Malaysia in a different emotional state than it exhibited during the first half of the decade. The confidence injected by prosperity has turned to gloom. Efforts at catapulting the country to the ranks of technically advanced nations by the 21st century have weakened and slowed down in the process of recession. The fall in the value of material commodities has raised doubts concerning accepted notions of the economic system.

The direction now is from within, inspired by a rich environment, traditions and cultures, rather than echoing trends from outside. This sense of conviction produces a centrifugal movement outwards, contrary to the time-worn centripetal drawing-in of artistic evolutions from without. This does not mean denying enrichment from outside. What it does mean is that creativity and artistic development come from the center itself and are not pale imitations of mainstream internationalism.

David Kamansky, Director of the Pacific Asia Museum, selected 41 works by 41 artists during his visits to Malaysia for an exhibition of Contemporary Malaysian Art at the Pacific Asia Museum in Pasadena. Three-quarters of the paintings were done within the last five years. The selection is a good survey of current Malaysian painting.

Mohd Hoessein from Indonesia is regarded as the father of portrait painting in Malaysia. His work continues the tradition of figurative painting which the Indonesians inherited from the Dutch.

Hoessein's portraits were much sought after in the sixties, and he had a following among a number of Malay artists. Figurative painting in the realistic tradition was revived in the early eighties with works by Samjis and Amron Omar (represented here with his "Self Portrait" [1982], #27.

The human figure is expressed in its varied forms in the works by Khalil Ibrahim in rhythmic color, such as his "Rhythm of Life" (1987) #17. Lately, Khalil has "loosened" his forms which previously were flat areas of dense coloristic intensity.

A newcomer to the Malaysian art scene is Wong Hoy Cheong, whose name made an impact on the local art scene in Merdeka (Independence) Open Art Show held in the National Art Gallery early in 1987, with bold design and strong, raw colors in the expressionistic idiom. As with the German Expressionists, the works have an underlying social message. In this exhibition, he is represented by "An Old Tale Retold" (1984) #39.

Redza Piyadasa, the enfant-terrible of the Malaysian art scene of the seventies, with his conceptual inquiries into the mysteries of mystical-reality (along with Sulaiman Esa) and his condemnation of art works as commercially viable commodities, currently presents a series of collages on the theme of the various ethnic groups. His "Baba Family" (1986) #30 is set within a cultural context imbued with nostalgia.

The art of water color painting which was inherited from the British is revived with renewed interest especially with the recent formation of the Malaysian Water Colour Society. In the figurative work, "Heritage 2" (1986) #15, Shafie Hassan presents a rural Malay family with socio-political undertones. The work typifies representational watercolors which tend to degenerate into touristic souvenirs.

The figure plays the role of pictorical protagonist in the works of Malaysian batik painters. Chuah Thean Teng first experimented with batik as a medium of pictorical expression in the fifties. The artist is still a master of the art of batik painting. In "Cowherd" (1986) #9, the artist continues his idyllic rural scenes with an ethnic folksy flavor. Teng is the master in interplay of decorative motifs and pictorial space creating a dichotomy of realities.

Another artist who comes from the beautiful island of Penang is Tay Mo-Leong, whose recent batiks in dark colors produce stained glass-like works. "Palms" (1986) #37 is typical of his current work.

Two batik artists in this exhibition have broken away from the

"Teng tradition". They refer back to traditional regional motifs as sources for pictorial imagery.

Syed Shaharuddin Bakeri has studied traditional batik motifs, colors and design and paraphrases them in a new way. His juxtaposition of forms set in newly differentiated pictorial space result in innovative works with surrealistic qualities, as witnessed in "Fabric in Red, Blue and Green" (1982) #3.

Fatimah Chik emphasizes decorative elements in tight, symmetrical arrangements of rectangular and triangular shapes influenced by regional flavor in her "Nusantara Series Temples" (1986) #7.

Lim Koon Hock's "Resting"(1986) #22 is a sensuous rendition of the female form rarely presented in Malaysian art. The soft colors and gentle lines are reminiscent of Japanese colored wood-cuts.

The paintings of Khoo Sui-ho of the sixties bridge the works of representational and abstract art. His dreamlike landscapes, transformed from the known environment, are peopled by mysterious figures, such as "Girl Holding Flower" (1964) #19. The forms in his paintings echo those of Abdul Latiff Mohidin. The artist's figures were later "lost" in the mists of Cameron Highlands.

Among the artists who made the headlines in the 60s was Dzulkifli Buyung. Hailed as a prodigy, he was a teen-age sensation of the Malaysian art scene and the darling of the Kuala Lumpur art circle. Dzulkifli's world of the child with its innocent activities is represented here with "Paper Boats" (1965) #4.

Zulkifli Dahalan was Dzulkifli Buyung's counterpart in the 70s, though presenting a different genre. Son of a one-time religious zealot, Zulkifli presents pictorial protestations against hypocrisy in society. In "Separate Realities" (1975) #11, the figures in his large painting are stripped of the trappings of status. The message is appropriately expressed in cheap, black enamel on crudely painted white board. The painting was done two years before the artist's death at the early age of twenty five.

Another artist with the human figure central to his pictorial manifestation is Syed Thajudeen, who received his formal art education in India. The artist's paintings are populated by languid "Moghul" figures set in ancient landscapes. His paintings are imbued with a patina of age, reminiscent of the Ajanta cave murals of western India, represented in "The Beginning" (1986) #38.

In contrast to Syed Thajudeen, Nirmala Shanmughalingam devoted herself during the last few years to expressing the human predicament in adverse socio-political conditions, such as those in Vietnam,

Central America, Afghanistan, and Lebanon. "Beirut I" #32 typifies the artist's commitment to the cause.

Currently Ibrahim Hussein conjures flowing human forms in a magical interweaving of form and line. The "Ripples" (1987) #16, one of his aquasonic series, is active with dance-like energetic movement.

The main force in Malaysian art is abstract expressionism which vividly depicts the burgeoning spirit of the post-independence period. It is divided into two main groups of artists — those who emphasize the gestures of the free-flowing brush strokes and those who employ symbolic forms to individuate moods and events of the growing years. These artists are among the leading exponents of visual art in the Malaysian art scenes, heroically spearheading the progress of Malaysian art at a breathtaking pace. In just more than one decade, Malaysian art was transformed from the quiet fringes of outer provincialism into the mainstream of contemporary universal art reflecting the tempo and tide of a rapidly changing society — from that of a colonized people directed by "superior" aliens to a free people responsible for their own actions, aware of the complexities of self-determination.

The first artists to come back from the quest for knowledge and experience were Tay Hooi Keat and Syed Ahmad Jamal. In this exhibition Jamal's "The Heart of the Matter" (1982) #18, mediates through metaphors of images. The work is one of the "Gunung Ledang" series inspired by the mystical Mount Ophir of Malay legends.

Abdul Latiff travelled extensively in the Southeast Asian region, in Indo-China, Thailand, and Indonesia. His travels produced some of the most significant images in Malaysian art, the most impressive being his "Pago-Pago" series. In this exhibition, the artist is represented by "Memory of the North" (1965) #25, nostalgically evoking images of the region.

The ethnic images of Abdul Latiff's works are reflected in Awang Damit's recent works. In "Essence of Culture II" (1985) #2, the artist, after graduating from a local art school in the eighties, gives an impression of the Malaysian art scene during the last few years.

Choong Kam Kow has been among the leading Malaysian artists since graduating in the late sixties. He has developed from the hard-edge art of the seventies to hand-made paper forms, which reflect ethnic cultures. His "Rhythm of Growth" (1987) #8 was inspired by the art expedition to the Endau-Rompin Jungle Reserve.

Another accomplished artist is Lim Eng Hooi, whose sophisticated hard-edge paintings, such as "Mars Burnt Raw S.V.2" (1970) #21, is

metaphorically abstruse. Although he produces few art works, the results show consistently high aesthetic standards.

Long Thien Shih has gained considerable notoriety as an enfant-terrible of the Malaysian art scene with his erotic works ever since his return from abroad in the early seventies. The tradition lives on, albeit in a more subtle manner, with his sensuous "Lucid Dream" (1983) #23. A product of Atelier 17, he has produced some outstanding prints.

Another artist who gained notoriety with his graffiti paintings of the sixties is Joseph Tan. His post-Chicago period in the seventies resulted in large monochromatic paintings with a sense of monumentality in positing slow lateral movement. His recent works are immaculately executed landscapes which maintain the monumental scale reminiscent of Chinese painting as shown in "Memories of Dungan" (1987/8) #34.

The landscape has been the main arena of artistic expression for Yeoh Jin Leng, known for his long involvement in art education. Upon his return from art school overseas, his painting with broad strokes of color made an impact in Malaysia. His later works develop into abstract coloristic harmonies with vibrant qualities. His "Mother Earth" (1984) #40 shows a soft pregnant form which pulsates with luminous chromatic glow.

Another artist preoccupied with abstract landscape is Tang Hon Yin whose "Watermargin No. 58" (1985) #36 is typical of the artist's recent works with vast expanses of aerial topographical landscape. In this particular work, the artist combines a strictly two-dimensional view with that of sunglow on the horizon.

Two artists influenced by the rich heritage of Chinese painting are Chung Chen Sun and Cheong Laitong. The latter enriches the Malaysian art scene with his renditions of luxuriant tropical flora in vibrant sweeps of color, as in "Composition A" (1985) #5. On the other hand, Chung Chen Sun, the leading exponent of contemporary Chinese painting the country, wields powerful brush strokes of Chinese ink as in his "Human Essence" (1986) #10. The brush strokes evoke the subject matter itself.

When Azahari Khalid Osman returned from Europe in the early eighties, the dark colors, brooding form and mysterious labyrinthian innards of his painting, "Untitled" (1984) #29 did not get the desired response from the Malaysian public, who prefer bright colors. However, Malaysian sunshine and a two-year tenure as resident artist at the Public Bank in Kuala Lumpur 1985/6 helped the artist to produce a continuous body of works, brighter in color, yet still powerfully emotive.

In contrast to Azahari's somber forms, the open vista of Annuar Rashid's "Birth of Inderaputra" (1978) #31 found immediate positive reaction among Malaysian art lovers. Almost overnight, the young artist, then aged 20, was the new sensation of the Malaysian art scene, perhaps its brightest star yet. Masterly handling of medium, rhythmic movement, and spatiality, based on local legend with grand operatic scale, promise even greater things to come.

Ng Buan Cher has made slow but steady progress in Malaysia. Since the mid-eighties her spare, stark, desolate grey landscapes with subtle textures and delicate "tonal" nuances evoke a contemplative mood, reminiscent of Chinese painting of the Yuan period. Exhibit #26 "Deep Deep 2" (1983) shows a slightly different angle of her works.

Tan Tong's "Yin Yang 2" (1986) #35 shows Chinese pictorial aesthetics stretched to the barest ascetic limit. Negative space displaces the positive elements, creating spatial tension.

A number of Malaysian artists commit themselves to pure abstraction. Among the leading figures in this style is Sharifah Fatimah Zubir, whose paintings glow with luminous shapes floating in an expanse of chromatic space, as in "Rhythm & Rhyme" (1987) #33, resulting in a sonorous mood which induces contemplation.

Fauzan Haji Omar has included color and dichotomy of actual and pictorial realities in his "Layer Series" (1986) #28. The series exhibits involvement with the physical properties of material, staining qualities of pigment, and interplay of colors and planes.

Yusuf Ghani's abstracted works of the mid-eighties attracted immediate attention when they were first shown in Kuala Lumpur. The dynamic shapes which are violently released from the human form, showing traces of de Kooning and Pollock, have an immediacy which demands attention as evident in "Dance-Hilal" (1987) #14.

Lee Kian Seng has been involved with allegorical works elaborately and immaculately executed. His "Yin Yang Series SF 21 Rings of Fire" (1981) #20 vividly represents his batik/dye paintings with brilliant colors amidst rich, deep hues.

The recent works of Ismail Abdul Latiff evolve from the cosmos and mythological lore. The artist's "Valley of Lake Chini, Flight of Magical Golden Peacock" (1986) #1, exhibits the artist's involvement with graphic illustration.

Ever since his return from formal art education in Europe, Ismail Mohd. Zain is recognized as an erudite artist worthy of serious attention. The artist's recent works are set within the framework of Islamic aesthetics, which is central to the artistic involvement of a number of Malaysian artists. His work with the enigmatic title of

"Meanwhile, Tam Came In Her Mother's Laced Kebaya" (1986) #24, is imbued with nostalgia and cultural connotation.

Among those who work strictly within the parameters of Islamic pictorial aesthetics is Sulaiman Haji Esa. In "Nurani" (1983) #13, the artist uses pure geometric shapes in symmetrical, centralized, architectonic form in combination with traditional craft and contemporary aesthetics.

Ahmad Khalid uses the Arabic alphabet as a motif for pictorial expression, beginning with "Alif-Ba-Ta" series in 1981. His "Calligraphy in Space" (1987) #41, with a subtle sense of etherial spatiality, reflects the principles of "infinite-patterning", "denaturalization" and "dematerialization" in Islamic pictorial art.

The vast and rapid changes that have taken place — the events, the mood, the elation and anxiety — from the provincial atmosphere and quite rhythm of the early fifties to the fast tempo of the present are mediated through art, at times directly, at times obliquely. Art is not truth, but the veil through which truth is seen. Contemporary Malaysian art is an expressive form of the living national culture.

The Report of the International Symposium organized by UNESCO, "The Artist in Contemporary Society",[12] stated that the artist who lives in a society with rapid development is in a difficult position. The artist's work, based on the autonomy of the individual, clashes with a society moving towards general mass production and collectivization. But the contemporary artists cannot work in a vacuum. Picasso stated that art which does not live in the present will never live at all.[13] Art follows art. Yet, in order to accept a new work one must do more than perceive the formal elements, important though this may be. One must refer to the history of art.

One of the primary responsibilities of the artist is to sharpen our sensitivity to the world around us and within ourselves. Through mass media, more people now are acquainted with the arts. Contemporary Malaysian artists move in various directions of commitment, drawing material from myth and legends. They probe questions of identity, their cultural heritage, personal cosmology, the place of religion in artistic expression, the extension of calligraphic gestures, the physical properties of materials, and the dichotomy of traditional and contemporary values. On the thirtieth anniversary of Independence, art represents many values. The Malaysian art scene, especially in Kuala Lumpur, is extremely lively.

SYED AHMAD JAMAL
Director
National Art Gallery

NOTES

1. Houdin, J.P., *'Modern Art and The Modern Mind'*, The Press of Case Western Reserve Cleveland and London University, 1972, pp. 231

2. Report by the National Art Education Associations of the United States, 1961, pp. 239

3. Emilio Coia, *'The Scotsman'*, Glasgow, 18 September 1965

4. Art Critic, *'The Glasgow Herald'*, Glasgow, 18 September 1965

5. Sheldon Williams, *'New York Herald Tribune'*, Paris, 8 February 1966

6. After the General Elections of 1969 tension ran high when supporters of the opposition party provoked the sentivity of supporters of the ruling party, as a result of which racial riots broke out in Kuala Lumpur with loss of lives and property. The situation was quickly put under control before it spread to other parts of the country.

7. *'Tenggara'*, #4. 1969, Kuala Lumpur

8. *Watan'*, (Malay Language newspaper), Kuala Lumpur, 4 January 1986, 7 Januari 1986, 11 Januari 1986, 14 Januari 1986

9. *'Business Times'*, Kuala Lumpur, 2 February 1987

10. Moravia, Alberto, *'The Terrorist Aesthetic'* Harpers' Magazine, New York, June 1987, pp. 39

11. eg: i) Henry Matisse, *'Moroccan Landscape'*, 1911, National Museum, Stockholm

 ii) Paul Klee, *'The Harbor of Hammamat'*, 1914, Private Collection, Belp. (Switzerland)

12. *'The Artist in Contemporary Society'*, UNESCO, Paris, March 1975, pp. 1

13. MacMullen, Roy, *'Art, Influence and Alienation'*, The New American Library, New York, 1969

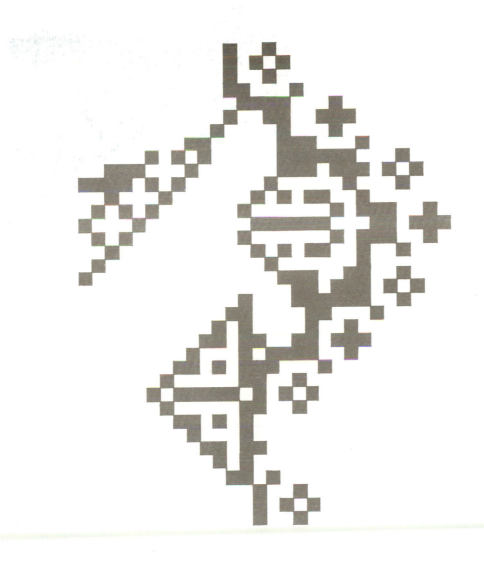

1. Ismail Abdul Latif
 'Valley of Lake Chini: Flight of Magical Golden Peacock', 1986
 Acrylic on paper
 37.4 x 91.8 cm
 Collection: Artist

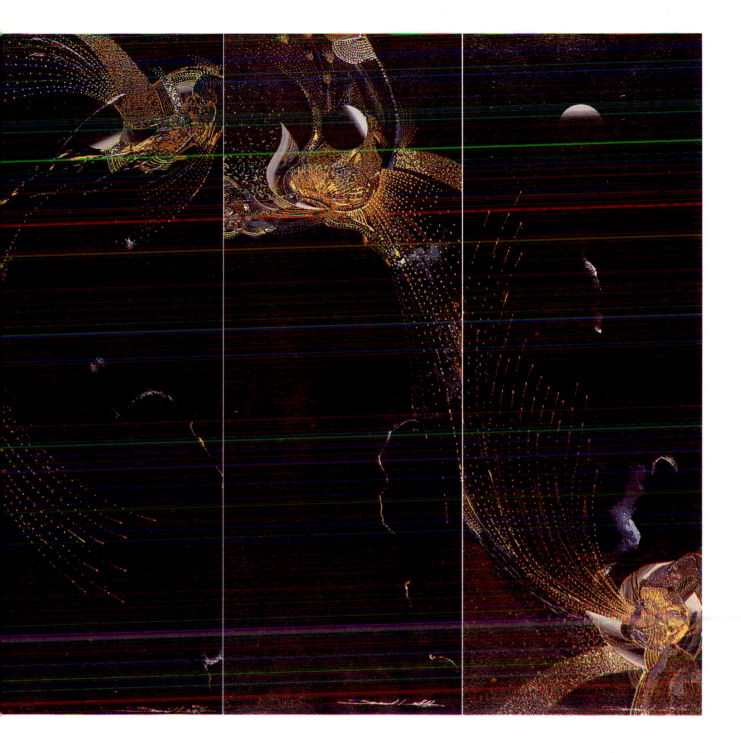

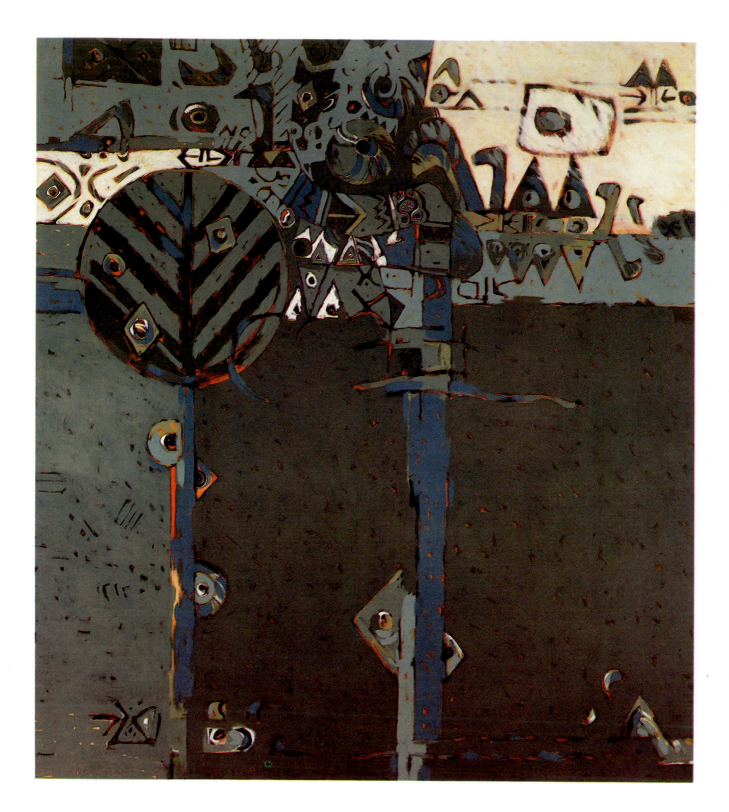

2. Awang Damit Ahmad
 'Essence of Culture 111', 1985
 Acrylic on canvas
 153 x 138.5 cm
 Collection: Artist

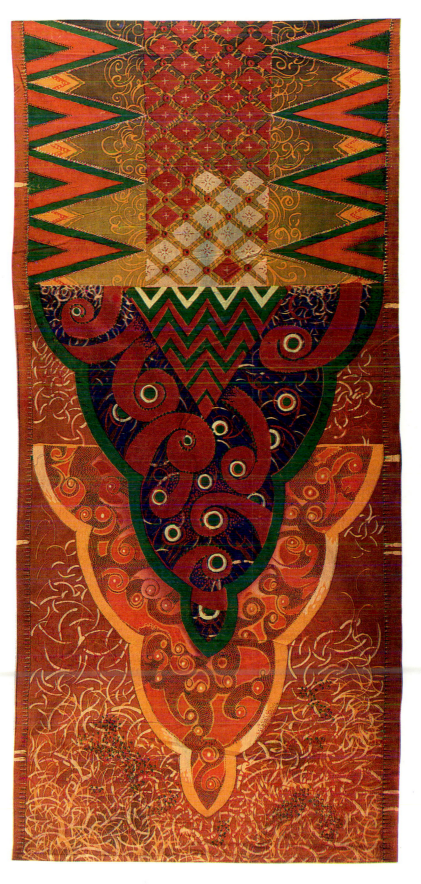

3. Syed Shaharuddin Bakeri
 'Fabric in Red, Blue and Green', 1982
 Batik
 225 x 102 cm
 Collection: National Art Gallery

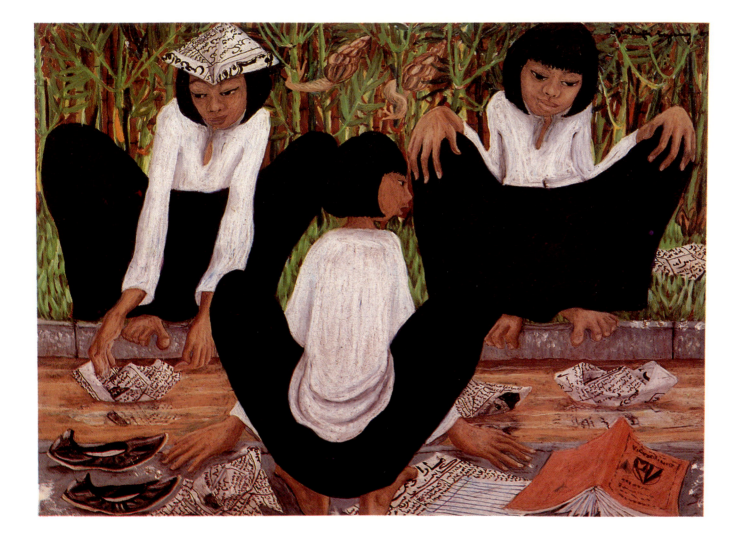

4. Dzulkifli Buyung
 'Paper Boats', 1965
 Pastel on paper
 55 x 75 cm
 Collection: National Art Gallery

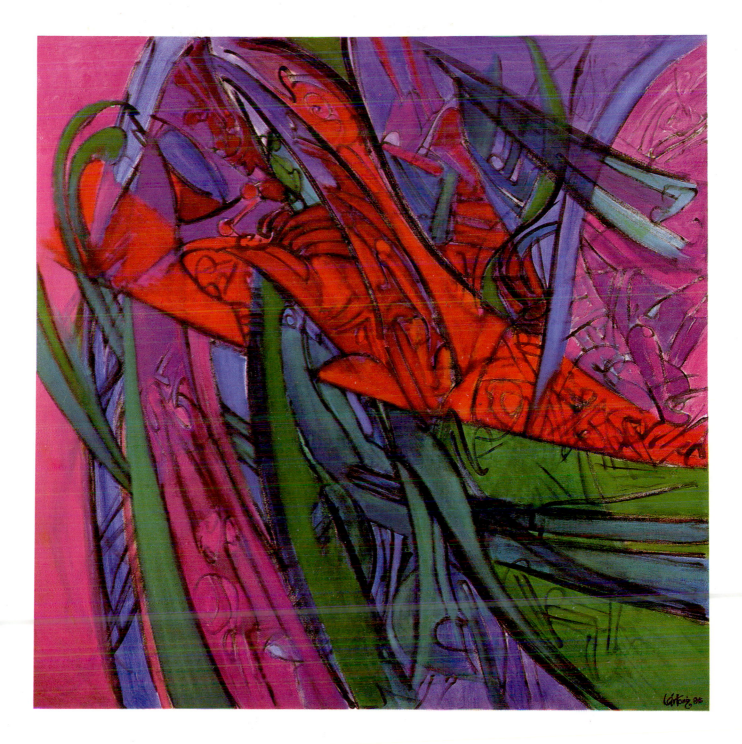

5. Laitong, Cheong
 'Composition A', 1985
 Acrylic on canvas
 135 x 135 cm
 Collection: Artist

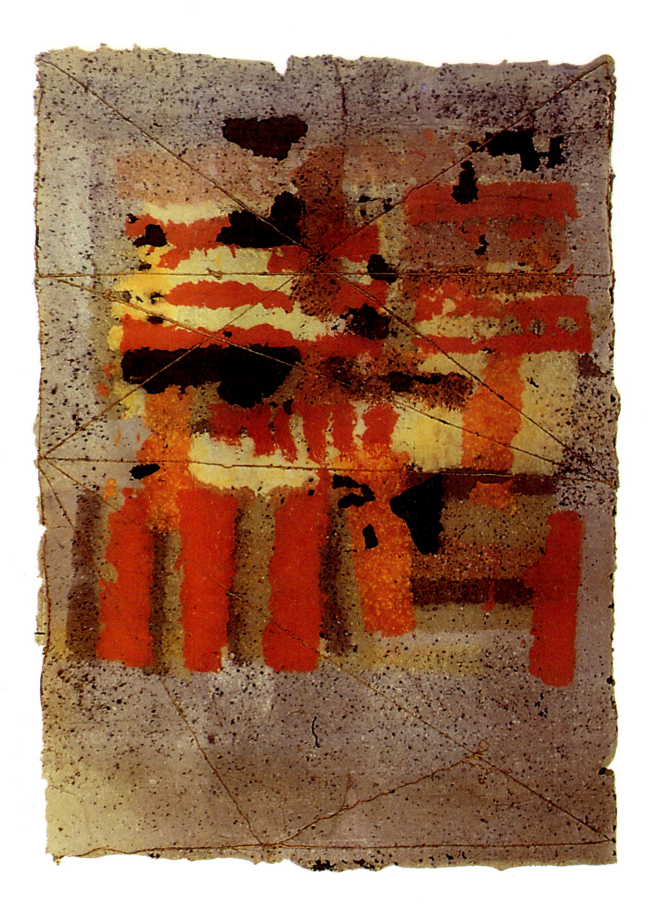

6. Teng Beng, Chew
 'Siew-Siew', 1978
 Handmade paper
 187.8 x 128.3 cm
 Collection: Artist

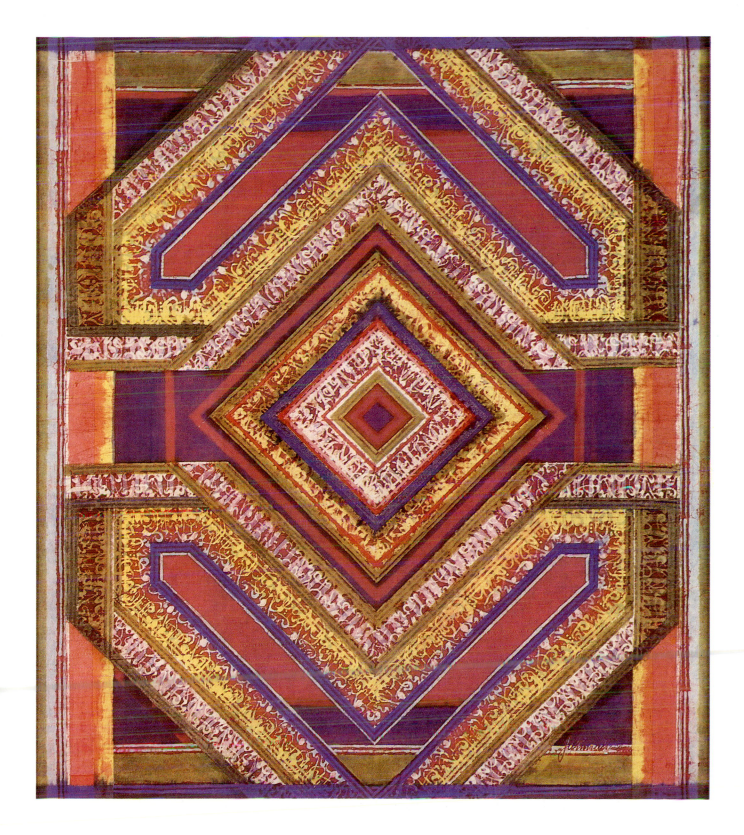

7. Fatimah Chik
 'Nusantara Series: Temples', 1986
 Batik
 120 x 90 cm
 Collection: Artist

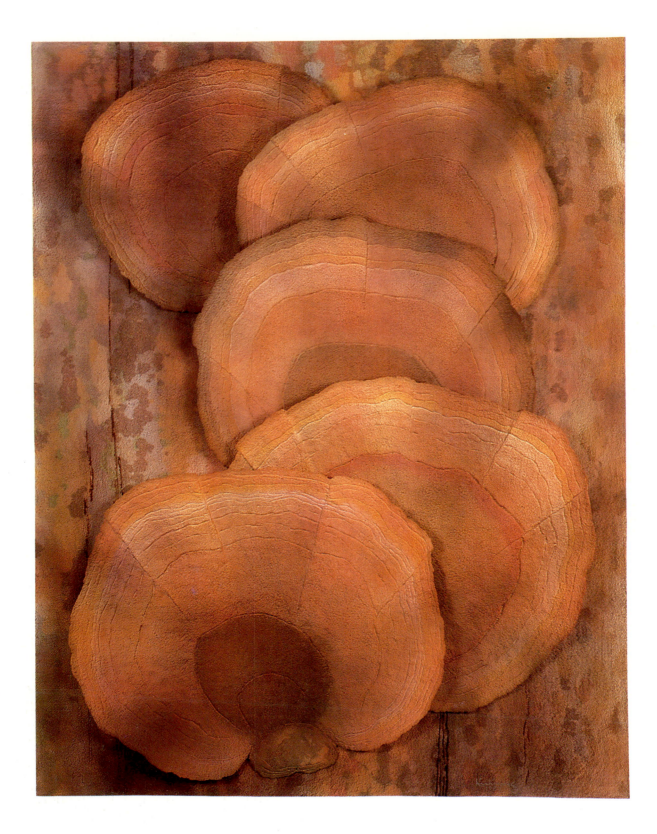

8. Kam Kow, Choong
 'Rhythm of Growth', 1987
 Mixed Media
 141 x 109 cm
 Collection: Artist

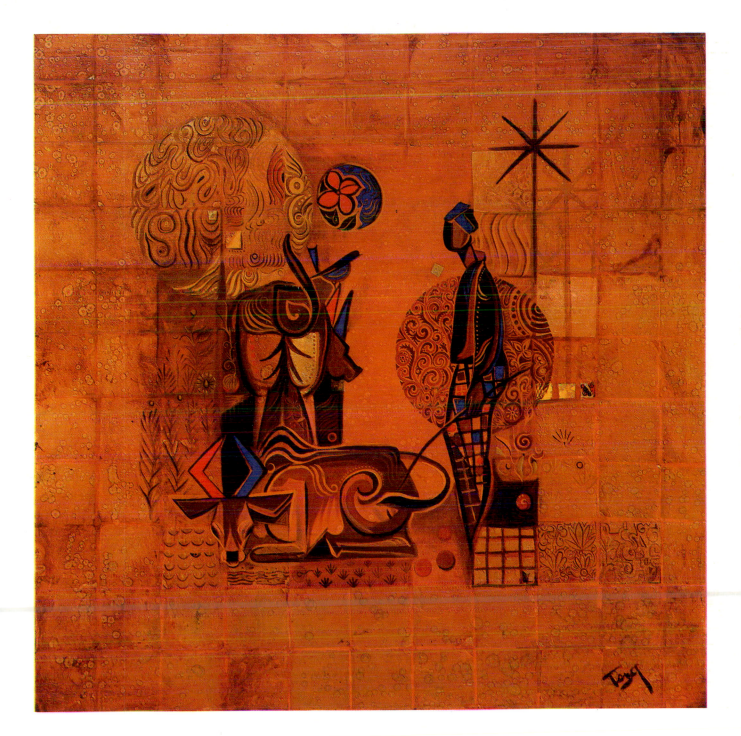

9. Thean Teng, Chuah
 'Cowherd', 1986
 Mixed Media
 115 x 115 cm
 Collection: Artist

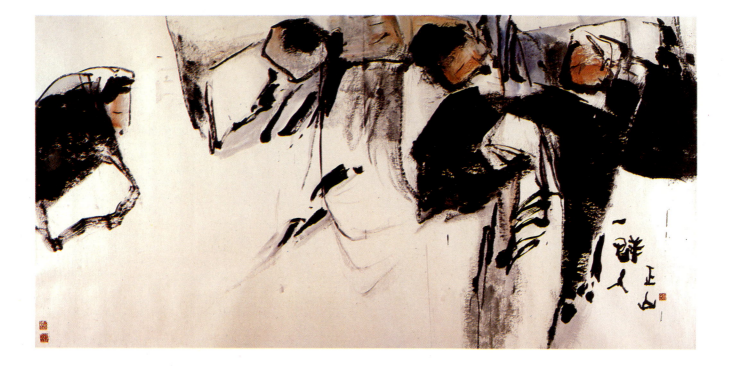

10. Chen Sun, Chung
 'Human Essence', 1986
 Ink on paper
 121 x 229 cm
 Collection: Artist

11. Zulkifli Dahalan
 'Separate Realities', 1975
 Enamel on board
 244 x 363 cm
 Collection: National Art Gallery

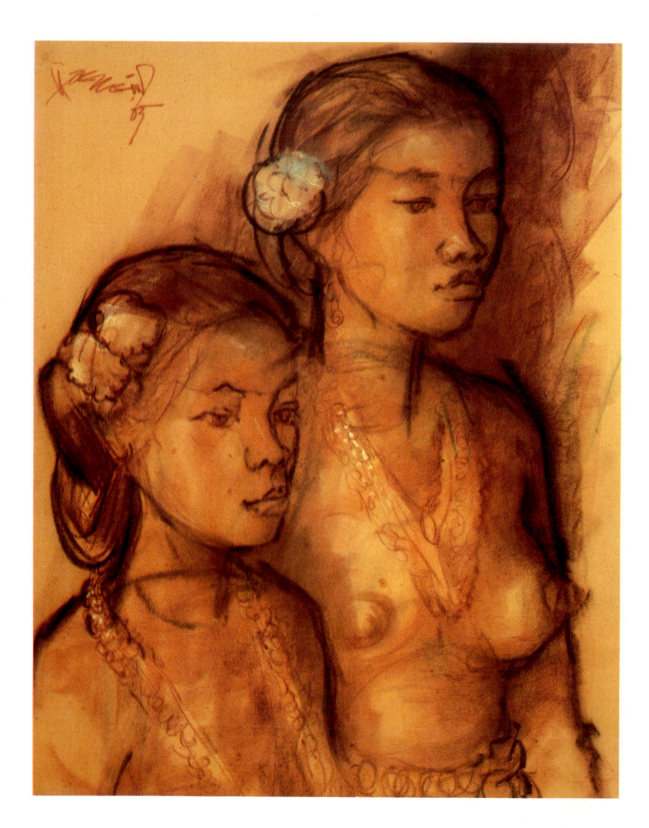

12. Mohd Hoessein Enas
 'Two Sisters', 1963
 Pastel on paper
 82.5 x 68.4 cm
 Collection: National Art Gallery

13. Sulaiman Esa
 'Nurani', 1983
 Mixed Media
 150 x 150 cm
 Collection: National Art Gallery

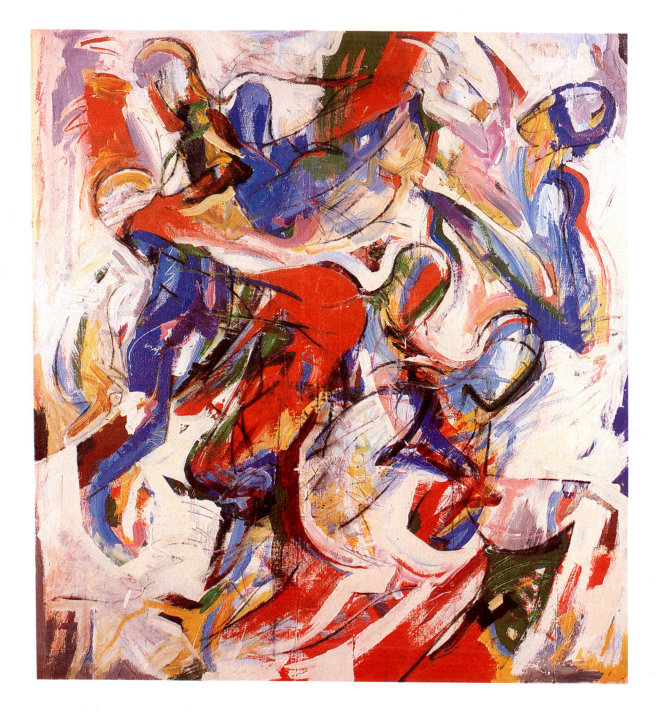

14. Yusuf Ghani
 'Dance-Hilal', 1987
 Mixed Media
 116.8 x 129.5 cm
 Collection: National Art Gallery

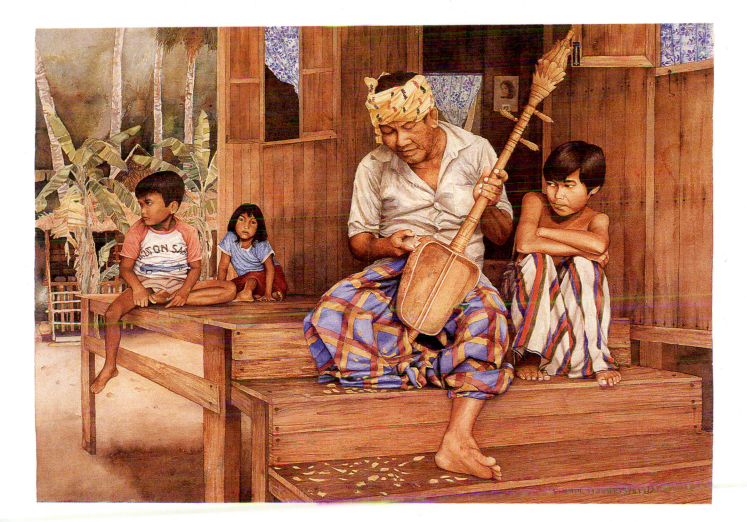

15. Shafie Haji Hassan
 'Heritage 2', 1986
 Watercolour on paper
 74 x 52 cm
 Collection: Artist

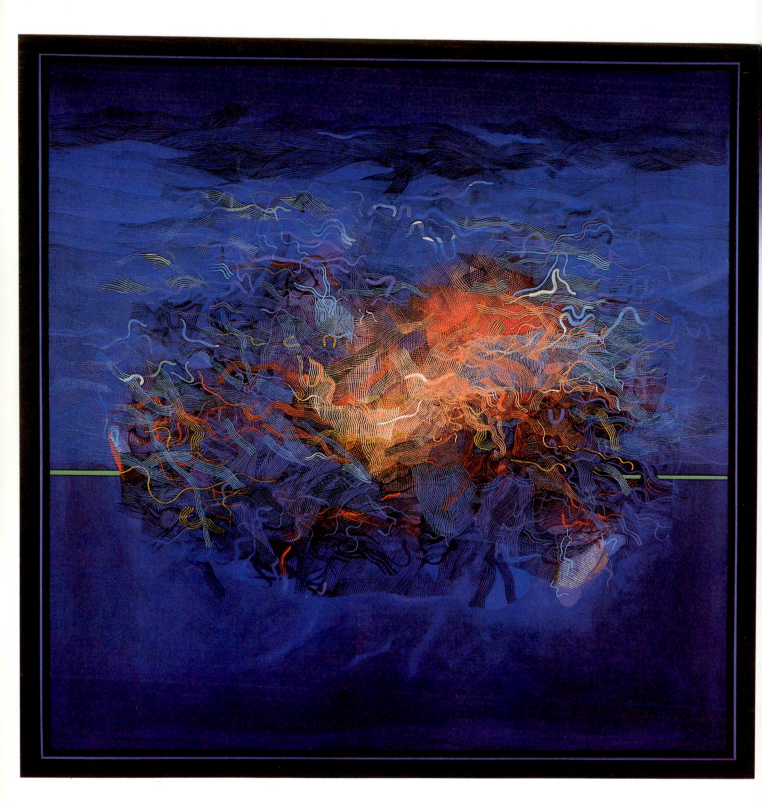

16. Ibrahim Hussein
 'Ripples', 1987
 Acrylic on canvas
 127 x 127 cm
 Collection: Artist

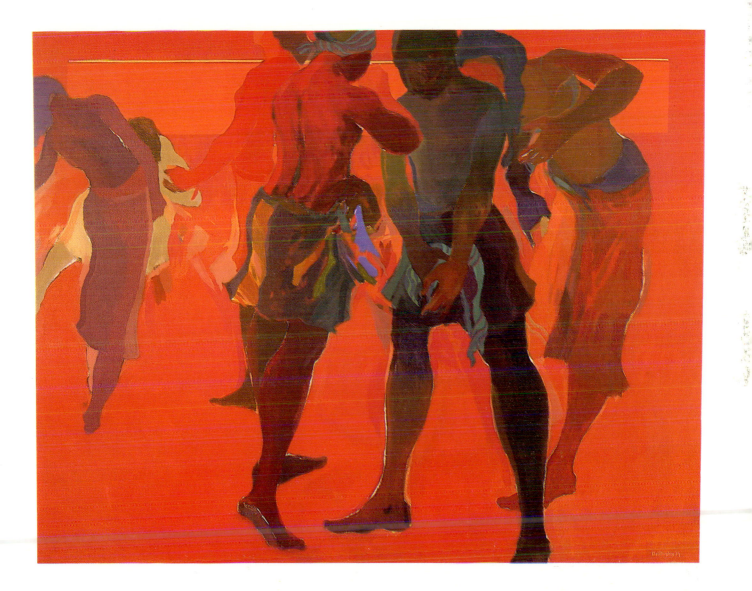

17. Khalil Ibrahim
 'Rhythm of Life', 1987
 Acrylic on canvas
 96.5 x 122 cm
 Collection: Artist

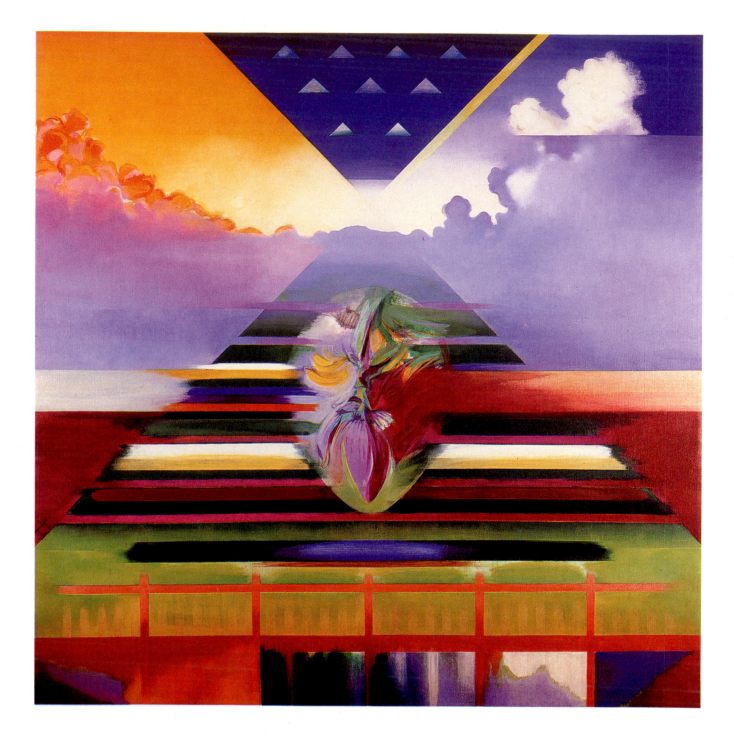

18. Syed Ahmad Jamal
 'Heart of Matter', 1982
 Acrylic on canvas
 203 x 203 cm
 Collection: Mr & Mrs Asmat Datuk Kamaluddin

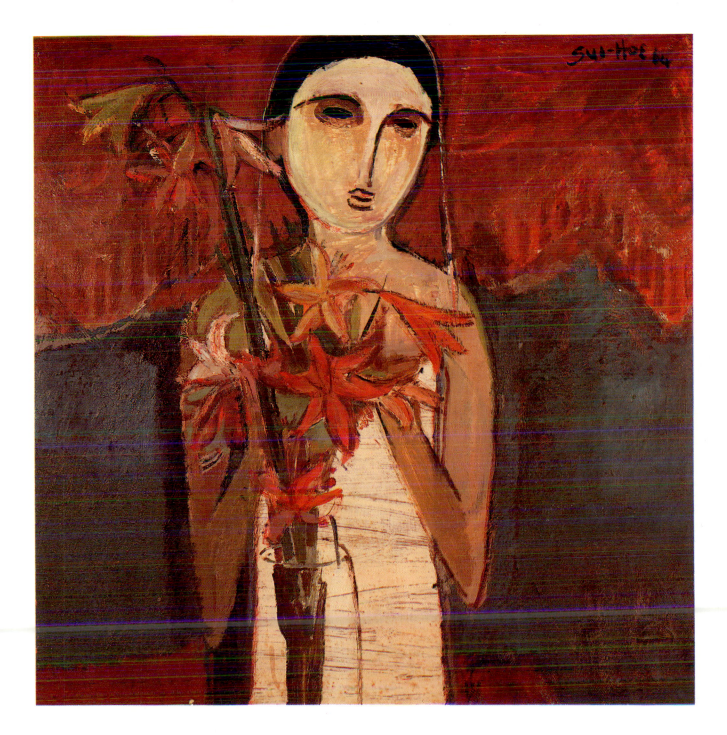

19. Sui-ho, Khoo
'Girl Holding Flower', 1964
Oil on board
82 x 82 cm
Collection: National Art Gallery

20. Kian Seng, Lee
'Yin Yang Series SF 21 Rings of Fire', 1981
Batik & Dye
86.3 x 173 cm
Collection: Artist

21. Eng Hooi, Lim
'Mars Burnt Raw S.V.2', 1979
Acrylic on canvas
203 x 203 cm
Collection: Artist

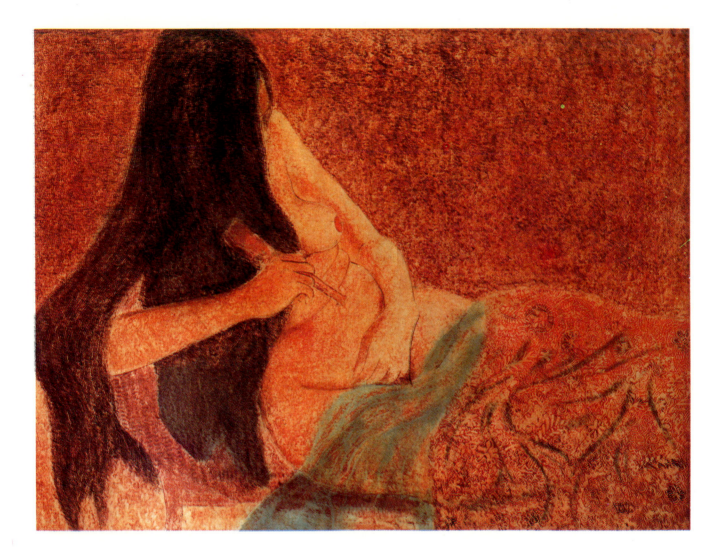

22. Khoon Hock, Lim
'Resting', 1978
Batik
50.5 x 66.7 cm
Collection: University of Science Malaysia

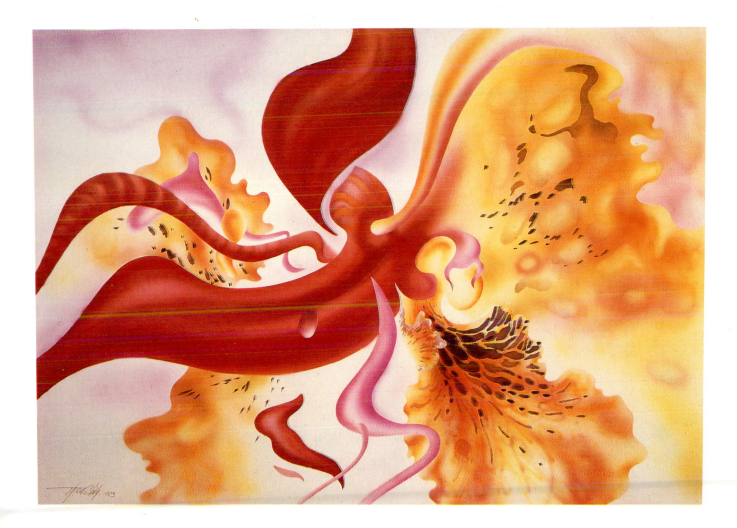

23. Thien Shih, Long
 'Lucid Dream', 1983
 Watercolour on paper
 63 x 91 cm
 Collection: Artist

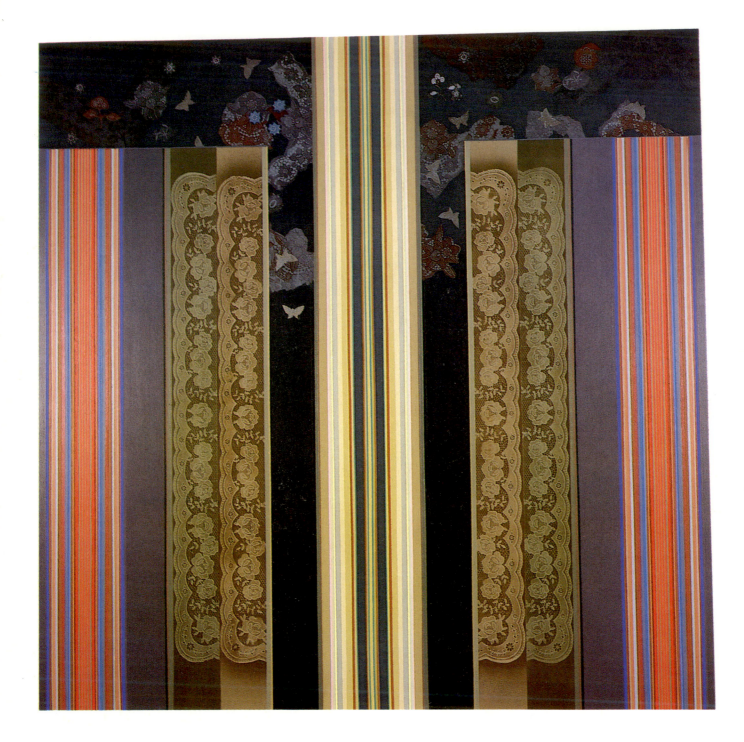

24. Ismail Mohd Zain
'Meanwhile, Tam came in her mother's laced kebaya', 1986
Acrylic on canvas
153 x 153 cm
Collection: Artist

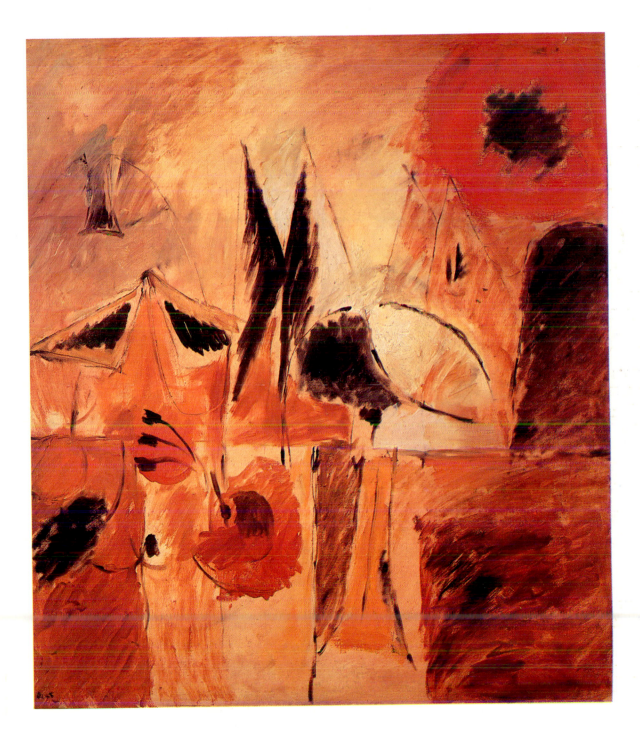

25. Abdul Latiff Mohidin
 'Memory of the North', 1965
 Oil on canvas
 91.5 x 80.5 cm
 Collection: National Art Gallery

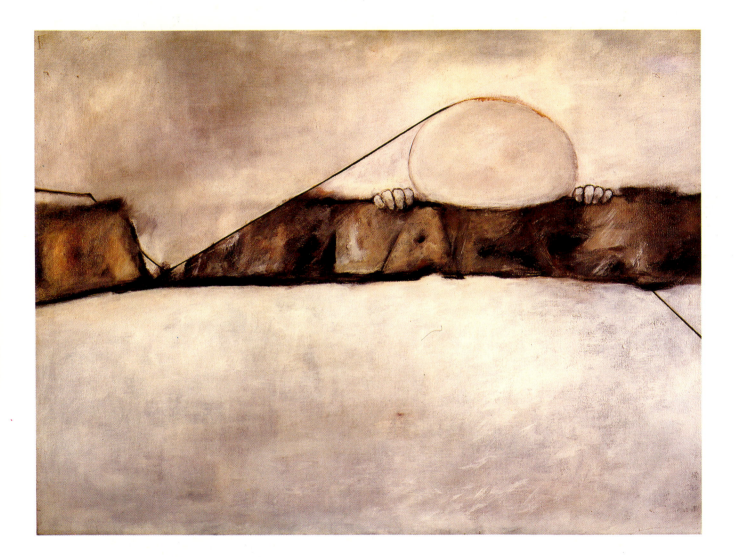

26. Buan Cher, Ng
 'Deep Deep 2', 1983
 Acrylic on canvas
 76.1 x 102 cm
 Collection: Artist

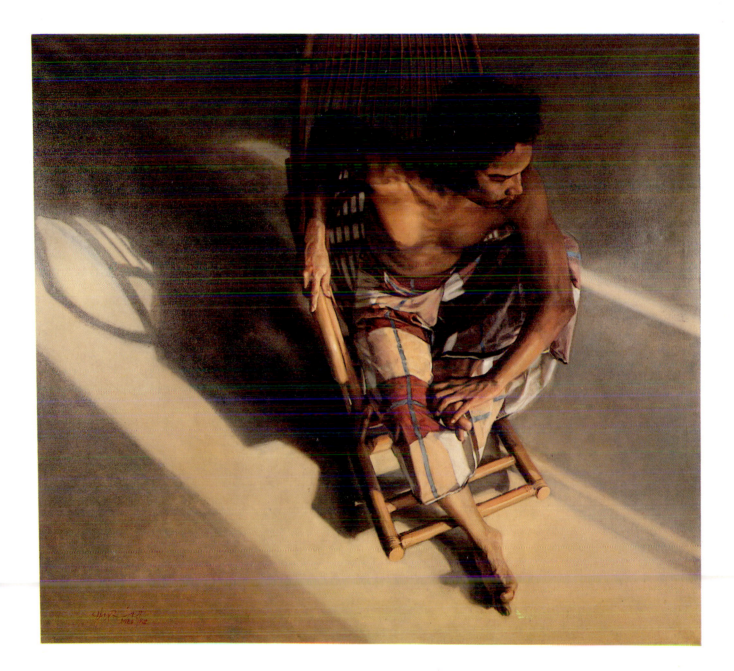

27. Amron Omar
'Self Portrait', 1982
Oil on canvas
143 x 157 cm
Collection: National Art Gallery

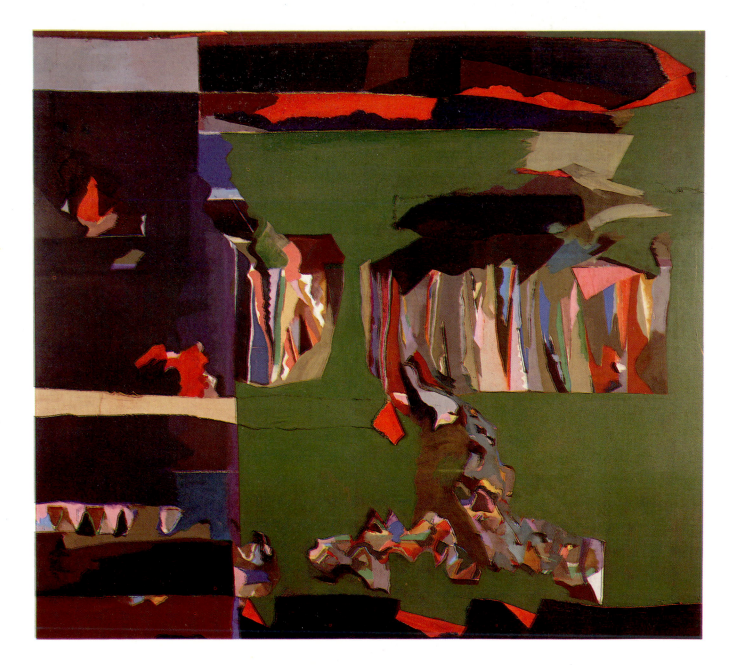

28. Fauzan Omar
 'Layer Series', 1986
 Mixed Media
 153 x 138 cm
 Collection: Artist

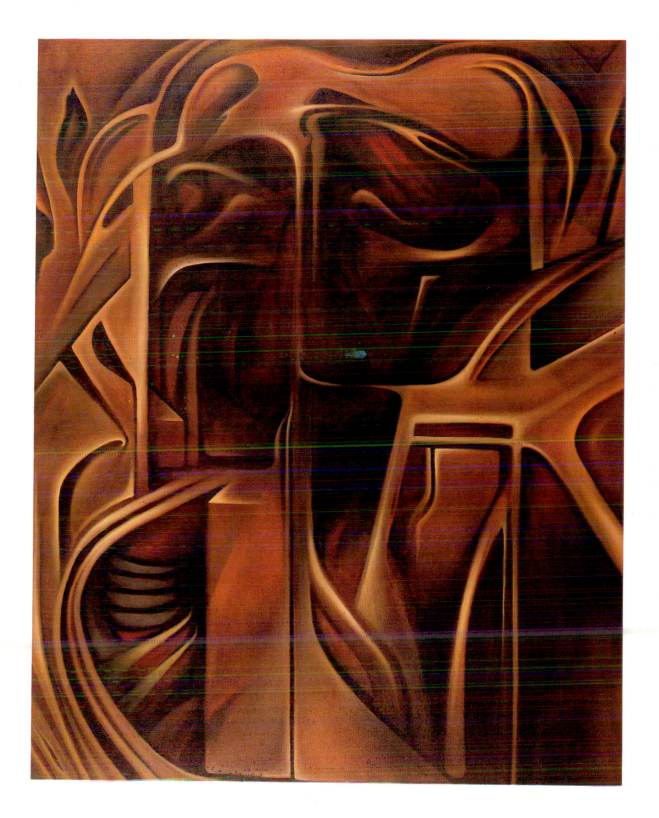

29. Azahari Khalid Osman
'Untitled', 1984
Oil on canvas
153 x 122 cm
Collection: National Art Gallery

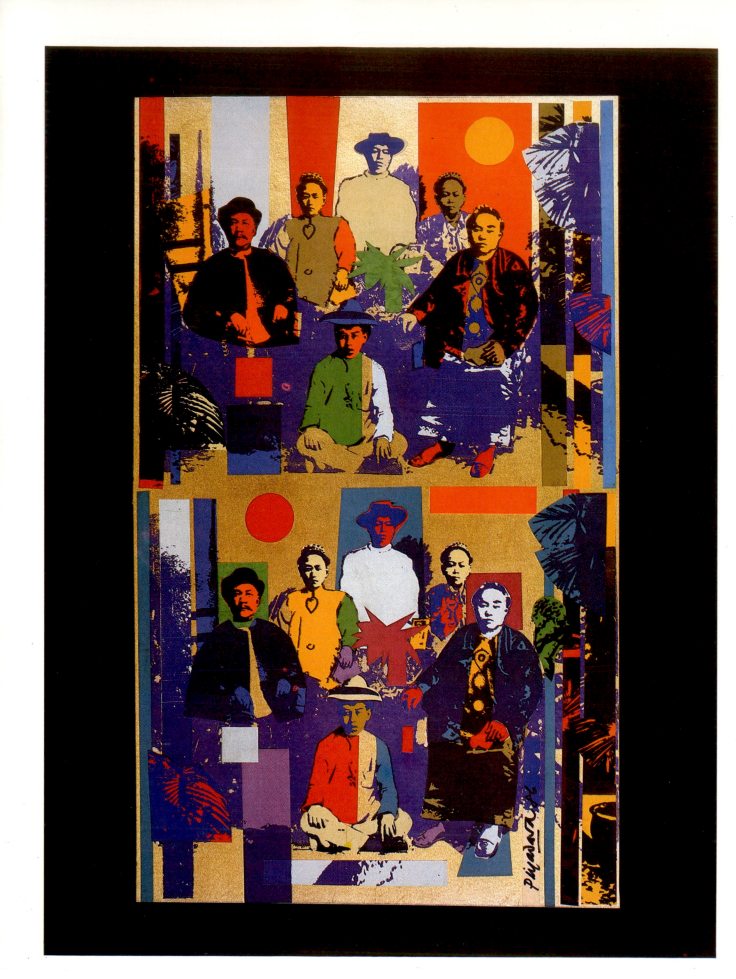

30. Redza Piyadasa
 'Baba Family', 1986
 Mixed Media, Collage
 110 x 82 cm
 Collection: Mr Jaafar Ismail

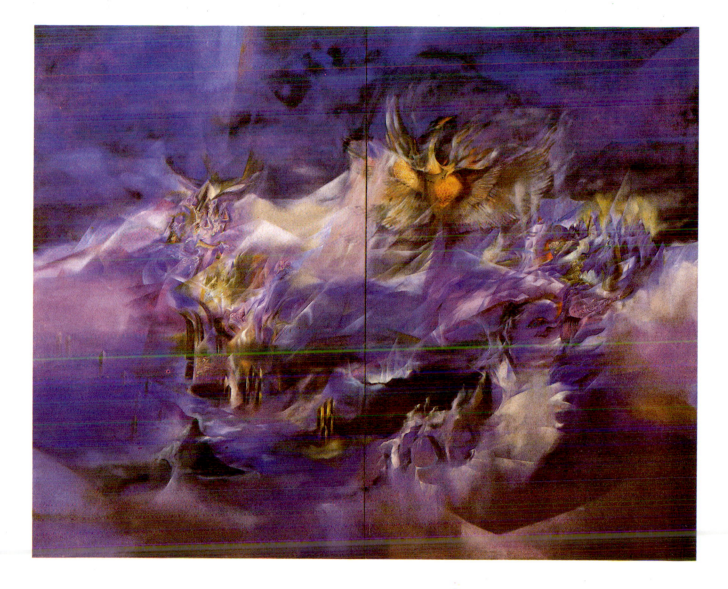

31. Anuar Rashid
 'Birth of Inderaputra', 1978
 Oil on canvas
 244 x 306 cm
 Collection: National Art Gallery

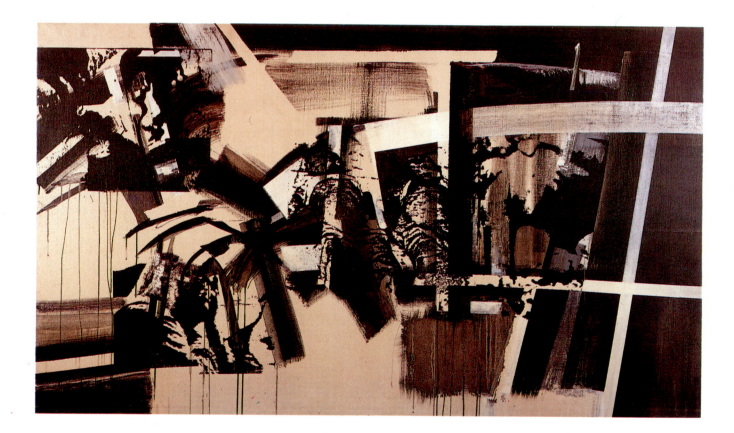

32. Nirmala Shanmughalingam
 'Beirut V', 1983
 Acrylic on canvas
 122 x 206 cm
 Collection: Artist

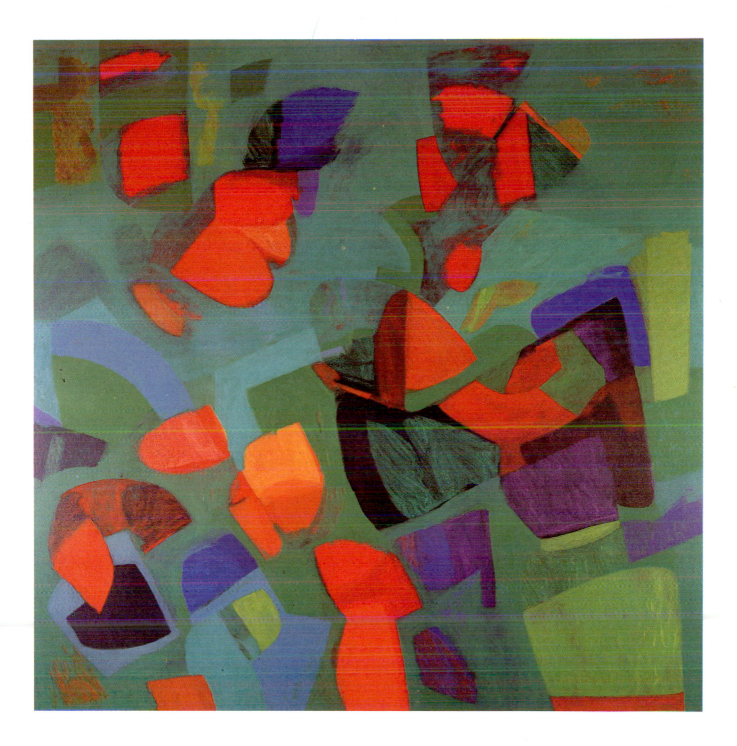

33. Sharifah Fatimah Syed Zubir
 'Rhythm and Rhyme', 1987
 Acrylic on canvas
 183 x 183 cm
 Collection: Artist

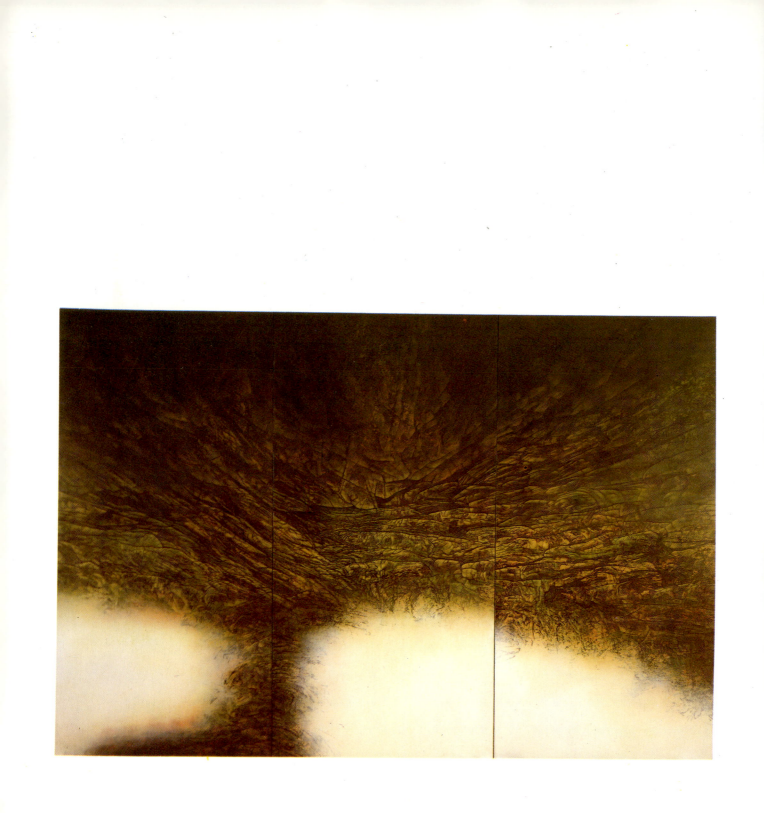

34. Joseph Tan
 'Memories of Dungun', 1987/88
 Acrylic on canvas
 183 x 274.3 cm
 Collection: Artist

35. Tong, Tan
 'Yin Yang 2', 1986
 Ink on paper
 120 x 60 cm
 Collection: Artist

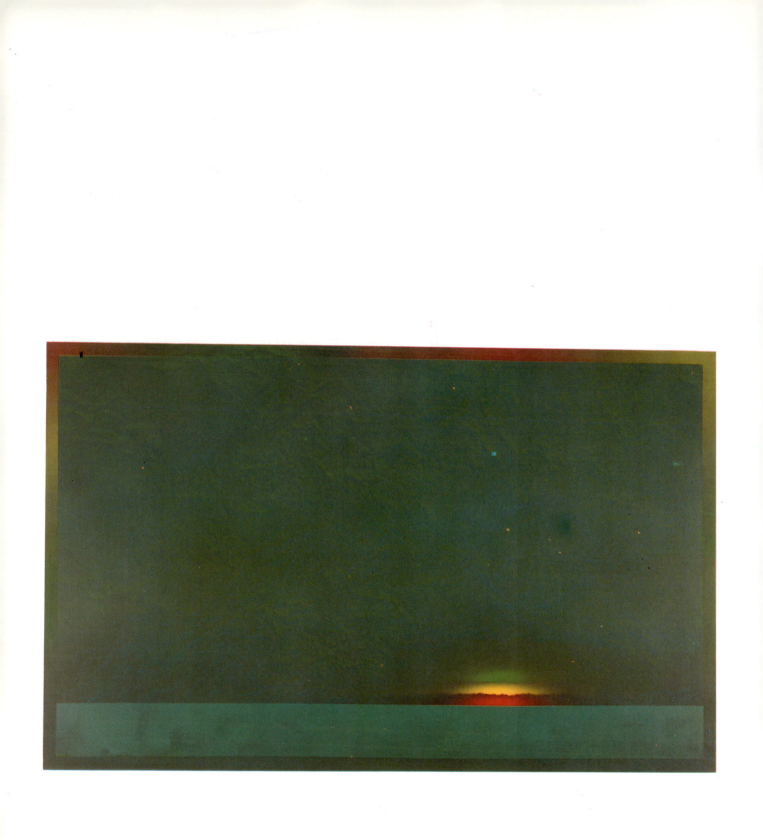

36. Hon Yin, Tang
 'Watermargin No. 58', 1985
 Acrylic on canvas
 126 x 200 cm
 Collection: National Art Gallery

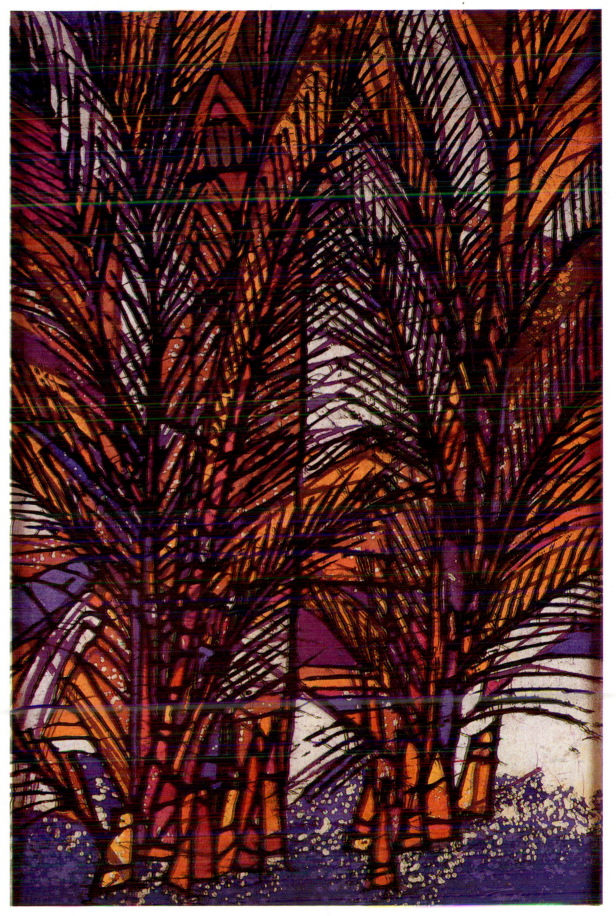

37. Mo-Leong, Tay
'Palms', 1986
Batik
91.5 x 61 cm
Collection: Artist

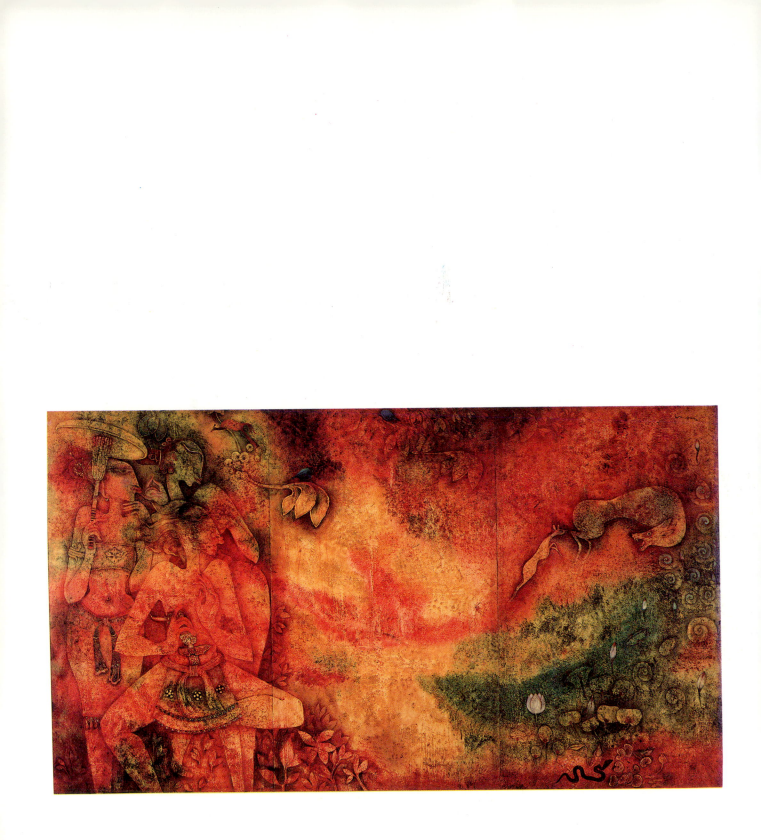

38. Syed Thajudeen
 'The Beginning', 1986
 Oil on canvas
 147 x 240 cm
 Collection: Artist

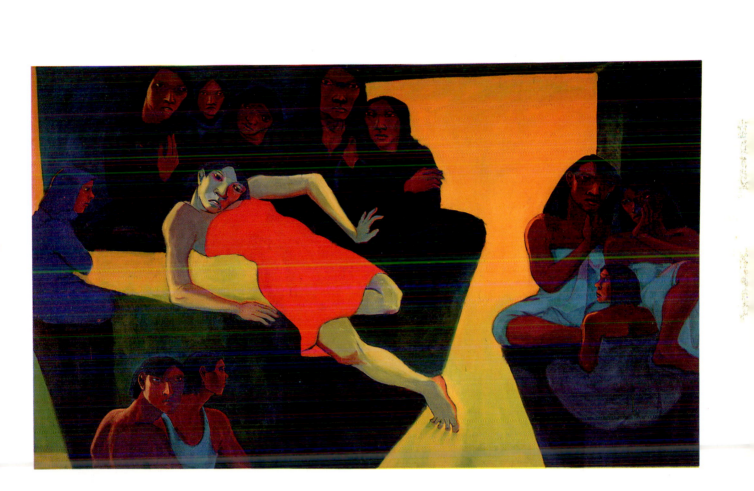

39. Hoy Cheong, Wong
 'An Old Tale Retold', 1984
 Oil on canvas
 163 x 270.5 cm
 Collection: Artist

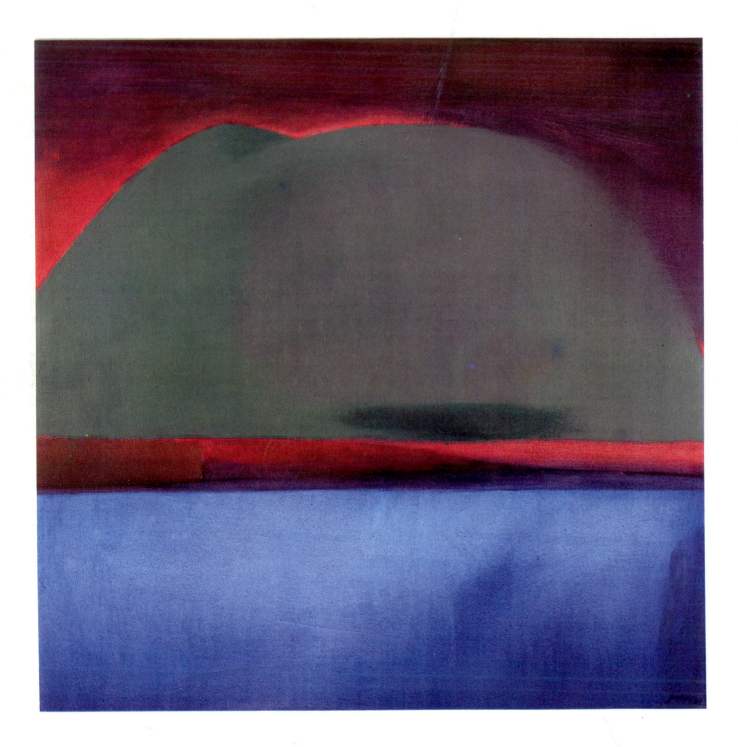

40. Jin Leng, Yeoh
 'Mother Earth', 1984
 Acrylic on canvas
 100 x 100 cm
 Collection: Artist

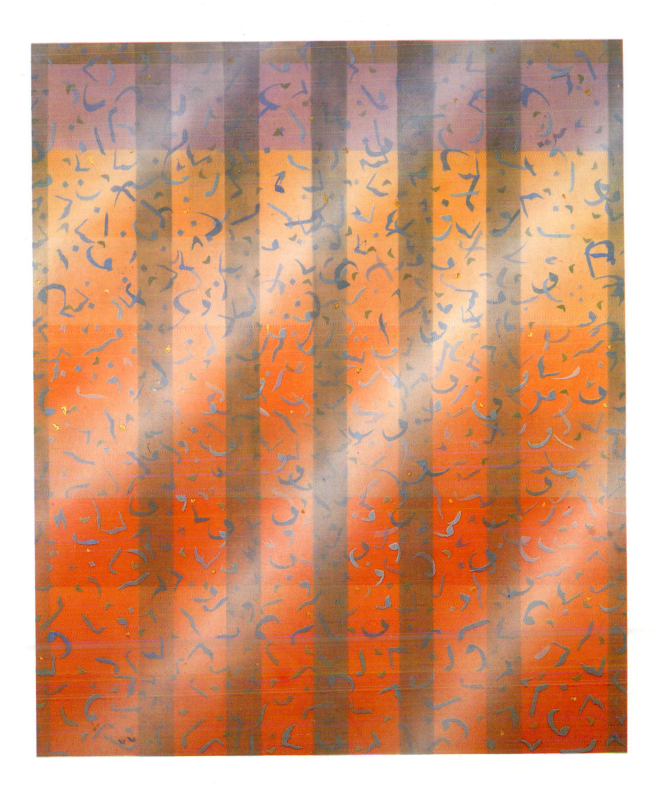

41. Ahmad Khalid Yusof
 'Calligraphy in Space', 1986
 Acrylic on canvas
 150 x 120 cm
 Collection: Artist

Biography

ISMAIL ABDUL LATIFF (b. 1955)

Born in Kampung Pulai, Malacca, 3 May 1955. Studied at MARA Institute of Technology, 1975-78. Participated in Travelling Exhibition of M.I.T. to States of Malaysia, 1977, 1978; 'Salon Malaysia', National Art Gallery, 1979, received Frank Sullivan Award; Art and Design Show, Dewan Bahasa & Pustaka, Kuala Lumpur, 1979; 'Sumbangan Art Exhibition', National University of Malaysia, 1980; International Graphic Art, Osaka University, Japan, 1980; Poster and Graphic Art Show, Warsaw, Poland, 1980; Group Show, Graphic Art, Kuala Lumpur, 1980; nominated for Young Artist of Asia in Japan, 1981; International Graphic Prints, Bangladesh Biennial, Dhaka, 1981; ASEAN Mobile Exhibition of Painting & Photographs, 1981; Young Illustrator of Asia, Melbourne, Australia, 1981; National Open Show, National Art Gallery, 1982, 1983, 1985, 1986; 'The Treatment of Local Landscape in Contemporary Malaysian Art, 1930-81', National Art Gallery, 1982; Exhibition of Prints, National Art Gallery, 1982; Recent Aquisition, 1980-82, National Art Gallery, 1982; One-Man Show, Hotel Equatorial, Kuala Lumpur, 1984; Group Show, Kuala Lumpur, 1984, 1985; 'Space', National Art Gallery, 1986; Malaysian Art 1957-87, National Art Gallery, 1987; National Open Show, National Art Gallery, 1988.

AWANG DAMIT AHMAD (b. 1956)

Born in Kuala Penyu, Sabah, 3 May 1956. Studied at MARA Institute of Technology, 1979-83.

Participated in 'Concept '85', City Hall, Kuala Lumpur, 1983; the 'Young Contemporaries', National Art Gallery, 1983; ASEAN Mobile Exhibition of Paintings & Photographs, 1984; National Open Show, National Art Gallery, 1984; Exhibition of Paintings & Calligraphy, National Art Gallery, 1984; National Open Show, National Art Gallery, 1985, 1986, 1987; Group Show — Malacca Artists, Admiral Hotel, Malacca, 1985; PNB Art Exhibition, PNB Building, Kuala Lumpur, 1985; The 'Young Contemporaries', National Art Gallery, Won Minor award, 1985; Faculty Show, National Art Gallery, 1985, 1987; 3rd Asian Art Biennale, Dhaka, Bangladesh, 1986; Malaysian Art 1957-87, National Art Gallery, 1987; National Open Show, National Art Gallery, 1988.

SYED SHAHARUDDIN BAKERI (b. 1947)

Born in Perak, 1947. Studied at Specialist Teacher's Training Institute Kuala Lumpur. Included in Exhibition of Paintings from Cheras, Kuala Lumpur, 1976; Modern Sculptures in Malaysia, National Art Gallery, 1976; 'Focus on Young Talents', National Art Gallery, 1977; 'Young Contemporaries',

National Art Gallery, 1977; 'Craft 1979', Kuala Lumpur, 1979; 'Salon Malaysia', National Art Gallery, 1979; 'Three-Man Art Exhibition', Kuala Lumpur, 1980; Premier Show, Malaysian Artists Association, University of Malaya, 1981; Young Contemporaries', National Art Gallery, 1981; 'Geraktara', Penang State Museum, 1982; National Open Show, National Art Gallery, 1982, 1984; Exhibition of Paintings, Prints & Sculpture from Private Collections, National Art Gallery, 1982; '25 Years of Malaysian Art', National Art Gallery, 1982; 5th Triennale-India, New Delhi, 1982; Exhibition of Paintings & Calligraphy, National Art Gallery, 1984; 'Fibre Art — Kuala Lumpur Arts Festival', Dayabumi, Kuala Lumpur, 1985; PNB Art Exhibition, awarded Major Prize in Batik, Kuala Lumpur, 1985; Malaysian Art 1957-87, National Art Gallery, 1987.

DZULKIFLI BUYONG (b. 1948)

Born in Kuala Lumpur, 1948. Self-taught, studied with the 'Wednesday Art Group', Kuala Lumpur, 1962-66; 'Young Artists' Exhibitions organized by the Arts Council, Kuala Lumpur, 1962-65; 'Frank Sullivan Collection' National Art Gallery, 1965; 'Contemporary Asian Art Exhibition, Kuala Lumpur, 1965; 9th National Art Exhibition, National Art Gallery, 1966; 'Malaysian Art' Touring Australia and New Zealand, 1969; 'Personal Choice', National Art Gallery, 1972; 'Malaysian Art 1957-1977', National Art Gallery, 1977; 'Malaysian Art 1965-1978' Commonwealth Institute, London, 1978; 'Treatment of the Local Landscape in Modern Malaysian Art 1930-81', National Art Gallery, 1982; Exhibition of Painting, Prints and Sculpture from Private Collection, National Art Gallery, 1982; '25 Years of Malaysian Art', National Art Gallery, 1982; National Open Show, National Art Gallery, 1984, 1985; Malaysian Art 1957-87, National Art Gallery, 1987.

LAITONG, CHEONG (b. 1932)

Born in Canton, China, 1932. Came to Malaysia in 1938. Studied: Skowhegan School of Art, 1960; Central School of Art, London, 1961. Participated in Annual Exhibition, Wednesday Art Group, Kuala Lumpur, 1952-60; National Loan Exhibition, National Art Gallery, 1958-63; 1st International Exhibition Saigon, 1962; One-Man Show, Kuala Lumpur, 1966; Malaysian Art Touring Europe, 1965/67; 1st Triennial India, New Delhi, 1968; 'Salon Malaysia', National Art Gallery, awarded Major Prize, 1969; 10th Sao Paulo Biennale, Brazil, 1969; Malaysian Art Touring Australia & New Zealand, 1969/70; 'Man and His World', Montreal Canada, 1970; 'Malaysian Art 1935-71', National Art Gallery, 1971; Abstract Expressionists of the 60s, National Art Gallery, 1974; 'Malaysian Art 1957-1977', National Art Gallery, 1977; National Open Art & Graphic Prints, National Art Gallery, 1977; 4th Triennial India, New Delhi, 1978; 'Malaysian Art

1965-78', Commonwealth Institute, London, 1978; 'Salon Malaysia', National Art Gallery, awarded Major Prize, 1979; One-Man Show, University of Malaya, Kuala Lumpur, 1981; Premier Show, Malaysian Artists Association, University of Malaya, Kuala Lumpur, 1981; 'The Treatment of Local Landscape in Contemporary Malaysian Art 1930-81', National Art Gallery, 1982; Exhibition of Painting, Prints & Sculptures from Private Collection, National Art Gallery, 1982; '25 Years of Malaysian Art', National Art Gallery, 1982; 'Geraktara', Penang State Museum, 1982; National Open Show, National Art Gallery, 1983, 1984, 1987; Contemporary Malaysian/British Art, National Art Gallery, 1986; Malaysian Art 1957-87, National Art Gallery, 1987.

TENG BENG, CHEW (b. 1938)

Born in Kuala Trengganu, 1938. Apprentice to his father, a commercial artist/teacher 1950-1956; studied at Teachers Training College 1959-1961; Specialist Teachers Training Institute 1964; Cranbrook Academy of Art, Bloomfield Hills, U.S.A. 1967-1968; B.F.A. (Hons) University of Michigan, Ann Arbor, U.S.A. 1968-1969; M.F.A. University of Michigan, Ann Arbor, U.S.A. 1969-1970; Ph. D. New York University, New York City 1983-1986. One-Man Shows: Samat Art Gallery, Kuala Lumpur, 1967; Allen Rubiner Gallery, Detroit, U.S.A. 1968; Forsythe Gallery, Ann Arbor, U.S.A. 1969; Georgetown Gallery, Washington D.C. 1969; Little Gallery, Birmingham, 1969; The International Monetary Fund, Washington D.C. 1970; Studio Angelico Little Gallery, Adrian, U.S.A. 1971; Goshen College Art Gallery, Indiana, 1971; Forsythe Gallery, Ann Arbor, 1972; Universiti Sains Malaysia Museum and Gallery, Pulau Pinang, Malaysia 1972, 1978; East & West Art, Victoria, Australia, 1980; Greenhill Galleries, North Adelaide, South Australia, 1980. Participated in all major exhibitions in Malaysia and Singapore 1957-1967; 'Mainstream 1968'. The first Annual Marietta College International Competitive Exhibition, Ohio, 1968; The 4th Bucknell National Annual Drawing Exhibition, Pennsylvania, 1968; The Michigan Watercolor Society 22nd Annual and Travelling Show, Michigan, Kansas, Wisconsin, 1968; Cranbrook Summer Show, Galleries Granbrook, Annual Regional Art Exhibition and Conference, University of Michigan, 1968; Art for Collectors, Bloomfield Art Association, Michigan, 1968; Huntington Woods Art League, Temple, 1968; BAA First Juried Exhibition of Michigan Painting, 1968; Fulbright-Hays Recipient 1967-1968; awarded First Prize: BAA 1st Juried Exhibition of Michigan Painting 1968; Michael A. Gormon Scholarship for advanced painting Cranbrook Academy of Art, Bloomfield Hills, 1968; The Departmental Scholarship, The University of Michigan, Ann Arbor 1968-1969; Teaching Fellowship, The University of Michigan, Ann Arbor, 1969-1970; included in the 10th Biennale, Sao Paulo, Brazil, 1969; Travelling Malaysian Art Exhibition, Australia and New Zealand, 1969; Young Artists Around the World, Union Carbide, New York, 1969;

The Art Society of the International Monetary Fund, 7th Annual Show, Washington D.C. 1969; Lydia & Harry Winston Collection, Krannert Museum, Illinois, 1969; The Museum of Art Exhibition, University of Michigan, Ann Arbor, 1969; The Pontiac Creative Center Invitational, Pontiac, 1969; Friends School in Detroit Invitational, Detroit, 1969; Man & His World, Montreal, Canada, 1970; 13th National Invitational Art Exhibition, National Art Gallery Kuala Lumpur, 1970; Lenawee Fine Arts Association Invitational, Michigan, 1970; Awarded Siena Heights College Art Department Award of the Year — The Most Dedicated Teacher, 1970; participated in Flint Art Fair, Flint, U.S.A. 1971; Cranbrook Gallery Go; Galleries Cranbrook, Bloomfield Hills, 1971; Art Train Project, Michigan, 1971; Siena Heights College Art Faculty, Michigan, 1971; Siena Heights Invitational, Michigan, 1972; Michigan Water Color Invitational, Detroit, 1972; Annual Invitational Exhibition, National Art Gallery Kuala Lumpur, 1973; 9th Annual Penang Art Gallery Exhibition, 1973, 19th Annual Penang Arts Council Exhibition, 1973; Malaysian Art 1957-1977, National Art Gallery, Kuala Lumpur, 1977; Open Art and Graphic Prints Competition, National Art Gallery, Kuala Lumpur, 1978; Malaysian Art 1965-1978, Commonwealth Institute, London, 1978; received the Australian Government Cultural Award, 1978; included in 8th International Art Exhibition, Singapore, 1979; Salon Malaysia, National Art Gallery Kuala Lumpur, 1979; The Art Exhibition of the Tenth Anniversary of University of Science Malaysia, Penang, 1979; Museums and Art Galleries of the Northern Territory NZV Building, Darwin, 1980; Contemporary Asian Art Show, Fukuoka Art Museum, 1980; 25 Years of Malaysian Art, National Art Gallery Kuala Lumpur, 1982; Exhibition of Prints, National Art Gallery Kuala Lumpur, 1982; Legends and Analogies of Printmaking: Past and Present, New Jersey Museum of Archaelogy, Drew University New Jersey, 1984; International Prints Exhibition, Chiengmai University, Chiengmai, Thailand, 1987; Malaysian Art 1957-87, National Art Gallery, Kuala Lumpur, 1987; Exhibition of Paper Artworks, Galeri Citra, Kuala Lumpur, 1987; National Open Show, National Art Gallery, 1988.

FATIMAH CHIK (b. 1947)

Born in Pontian, Johor, 1947. Studied: School of Art & Design MARA Institute of Technology, 1968-71.

Exhibitions: Batik Design Exhibition, National Art Gallery, 1968; Exhibition of Hand-painted Batik organized by Kutangkraf, University of Malaya, 1972; 'Young Contemporaries', National Art Gallery, 1982; 'Titian 1', National Museum Art Gallery, Singapore, 1983; National Open Show, National Art Gallery, 1983-86; Group Exhibition, Museum & Gallery, University of Science Malaysia, Penang, 1984; Saujana Exhibition, Kuala Lumpur, 1984, 1985; 'Fibre Art', Kuala Lumpur Arts Festival, Kuala Lumpur, 1985; PNB Exhibition, Kuala Lumpur, 1985; Malaysian Artists'

Association Exhibition of Paintings, Australian High Commission, Kuala Lumpur, 1986; 3rd Asian Art Biennale, Dhaka, Bangladesh, 1986; 'Space', National LArt Gallery, 1986; Saujana Fine Arts Gallery, 1986; Malaysian Art 1957-87, National Art Gallery, 1987.

KAM KOW, CHOONG (b. 1934)

Born in Perak on 12th February 1934. Studied: Taiwan Normal University Taipei, 1961-65; Pratt Institute New York, 1966-68; received ACLS-Fulbright Research Fellowship in 1980/81.

One-Man Shows: International Center, New York, 1966 and 1967; Pratt Graduate Art Gallery New York, 1967; New Masters Art Gallery, New York, 1968; The Abacus Art Gallery, Providence, Rhode Island, 1968; Avis Rohr Gallery, Camden New Jersey, 1968; Dewan Bahasa & Pustaka Kuala Lumpur, 1970; Asian Art Museum, University of Malaya, 1975. Included in: Annual Art Exhibition, National Art Gallery, 1963, 1964, 1968, 1969, 1970; 'Four Artists Joint Show', Gallery of Modern Art, Frederisksburg Virginia, U.S.A., 1968; 'Expo '70' Osaka Japan, 1970; 'Malaysian Art 1931-71', University of Malaya 1970; 'National Invitation Exhibition' National Art Gallery, 1972; Modern Sculpture of Malaysia, National Art Gallery, 1976; 'Malaysian Art (1957-77)' National Art Gallery, 1977; 'Malaysian Art (1965-78)' Commonwealth Institute, London, 1978; 'Salon Malaysia' National Art Gallery, 1979; 1st Asian Art Biennale Dhaka Bangladesh, 1981; International Contemporary Ink Painting Exhibition, Kuala Lumpur, 1982; 'Titian 1', National Museum Art Gallery Singapore, 1983; National Open Show, National Art Gallery, 1983-86; International Ink & Brush Painting Exhibition, Taipei City Museum of Art, 1985; 2nd Asian Art Show, Fukuoka Art Museum Fukuoka Japan, 1985; Seoul Contemporary Asian Art Show, National Museum of Modern Art, Seoul, Korea, 1986; 'Space', National Art Gallery, 1986; Faculty Show, National Art Gallery, 1987; Malaysian Art 1957-87, National Art Gallery, 1987, National Open Show, National Art Gallery, 1988.

THEAN TENG, CHUAH (b. 1914)

Born in Amoy, China, 1914. Studied at Amoy Academy of Art, China, came to Malaysia in 1932. One-Man Shows: Arts Council, Penang, 1955; Singapore Art Society, 1956; Arts Council, Kuala Lumpur, 1957; Commonwealth Institute, London, 1959; Arts Council, Kuala Lumpur, 1963; Pomeroy Galleries, San Francisco, 1964; National Art Gallery, 1965; Commonwealth Institute, London, 1965; Municipal Gallery of Fine Art, Dublin, 1965; Arts Council, Kilkenny Castle, 1965; Arts Council, Cork, 1965; Lower Gallery, London, 1966; Stichting Twents-Gelders Textielmuseum, Engchede, Holland, 1967; Samat Gallery, Kuala Lumpur, 1967, Palm Spring, Gallery, California, 1972; Rinera Galleries, New South Wales,

Australia, 1972; Angle Art Centre, New South Wales, Australia, 1972; Kanda Gallery, Tokyo, Japan, 1975.

Participated in First International Art Exhibition in Saigon, 1962; Malaysian Art Touring Europe, 1965/67; Malaysian Art Touring Australia & New Zealand, 1969; 10th Sao Paulo Biennial, Brazil, 1969; 'Man & His World', Montreal, Canada, 1970; International Art Exhibition, Basel, Switzerland, 1974, 1975; Art Exhibition under the joint sponsorship R & I Bank, M.A.S. and T.A.A. in Melbourne, Sydney & Perth, Fremantle Art Centre, Australia, 1975; Art Exhibition at Churchill Gallery, Perth, Australia. Commonwealth Artists of Fame, for the Silver Jubilee of H.M. The Queen of England, 1977; Plastic Arts in Malaysia, 1957-1977, National Art Gallery, 1977; Malaysian Art 1965-1978, Commonwealth Institute, London, 1978; 'The Treatment of Local Landscape in Contemporary Malaysian Art 1930-81', National Art Gallery, 1982; 'Geraktara', Penang State Museum, 1982; Exhibition of Paintings, Prints & Sculptures from Private Collection, National Art Gallery, 1982; '25 Years of Malaysian Art', National Art Gallery, 1982; ASEAN Mobile Exhibition of Paintings and Photographs, 1982; Permanent Collection, Figurative Art, National Art Gallery, 1983; 12 Malaysian Artists Exhibition, National Museum of History, Taipei, 1985; ASPACAE '87, Art Exhibition, Gallery On-Tai, Kuala Lumpûr, 1985; National Open Show, National Art Gallery, 1987; Malaysian Art 1957-87, National Art Gallery, 1987.

CHEN SUN, CHUNG (b. 1935)

Born in Malacca, 1936. Studied: Nanyang Academy of Art, Singapore, 1952-1955; University of San Francisco, U.S.A., 1986.

One-Man Shows: First Solo, Malacca, 1954; Kuala Lumpur, 1967, 1969, 1976; Bangkok, Thailand, 1978; Toronto, Canada, 1979; Kuching, Sarawak, 1979; Kuala Lumpur, 1979; National Museum of History, Taipei, 1980; Museum of Chinese Culture University, Taipei, 1981. Participated in 6-Man Exhibition, Malacca, 1954; Local Artist Exhibition, Singapore, Awarded prize of Merit in Ink-Painting Competition, 1956; Singapore Arts Circle, 10th Year Exhibition, 1957; National Art Exhibition, National Art Gallery, 1958-1960; 4th International Contemporary Art Exhibition, New Delhi, 1961; 1st International Art Exhibition, Saigon, 1962; 6th National Art Exhibition, National Art Gallery, 1963; 2-Man Exhibition, Singapore Library, 1964; Contemporary Art in Asia Exhibition, visited 13 Asian Capitals, 1965; Waratah Spring Festival, Sydney, Australia, 1966; 10th National Art Exhibition, National Art Gallery, 1967; founded the Malaysian Institute of Art, 1967; 11th National Art Exhibition, National Art Gallery, 1968; Malaysian Art Touring Australia & New Zealand, 1969; X Sao Paulo Biennial, Brazil, 1969; 3rd Indian Triennial, New Delhi, India, 1970; 'Man and His World', Montreal, Canada,

1970; Malaysian Institute of Art Lecturer travelling exhibition in Malaysia and Singapore, 1971; The International Society of Plastic and Audio Visual Art, Kuala Lumpur, 1972; 'Man and His World', National Art Gallery, 1973; International Society of Plastic & Audio Visual Art, Osaka, Japan, 1974; Invitation Show, National Art Museum, Taipei, participated Asian Art Education Conference in Hong Kong, 1975; 'Malaysian Art 1957-1977', National Art Gallery, 1977; Invitation Show, National Art Museum, Taipei, 1977, 1979; 'Malaysian Art 1965-1978', Commonwealth Institute, London, 1978; Contemporary Asian Art Show, Fukuoka Art Museum, Japan, 1980; 1st Asian Pacific Conference on Art Education (ASPACAE), Taipei, 1981; Contemporary Chinese Ink-Painting Today, Paris, 1981; Visiting Professor, Chinese Culture University, Taipei, 1981; Founded the International Contemporary Ink-Painting Association (ICIPA) and elected as the 1st President of the Association, 1982; ICIPA 1st Exhibition, National Museum of History, Taipei, 1982; Awarded fellowship Academy of Tionghua, Chinese Culture University Taipei, 1982; 25 Years of Malaysian Art, National Art Gallery, 1981; ICIPA Exhibition, Kuala Lumpur & Singapore, 1983; 3-College Professors & Lecturers Joint Exhibition in Kuala Lumpur, Singapore & Taipei, 1983; Overseas Chinese Artists Exhibition, Taipei Fine Arts Museum, 1983; ASPACAE '83, San Francisco, California, 1983; Honour Award of the China Cultural Association, Taiwan, 1984; Modern Asian Ink & Colour Paintings Exhibition, Seoul, sponsored by The Korean Culture & Arts Foundation, 1986; Contemporary Chinese Paintings Exhibition, Hong Kong presented by the Chinese University of Hong Kong, 1986; Malaysian Art 1957-87, National Art Gallery, 1987.

ZULKIFLI DAHALAN (b. 1952, d. 1977)

Born in Kuala Lumpur, 24th July 1952, died 23 August 1977. Studied in Medan Sumatra, 1971. Resident artist of the Malaysian Art Group, 1973-74.

Participated in the Young Artist Exhibition sponsored by the Malaysian Art Group, 1968, 1971; Group Exhibition in Medan, Sumatra, 1971; Petaling Jaya Art Exhibition, 1972; 'Man & His World', National Art Gallery, awarded Special Prize, 1973; Group Exhibition at Taman Jaya, Petaling Jaya, 1974; 'The Young Contemporaries' National Art Gallery, awarded Major Prize, 1974; Anak Alam 1st Graphic Exhibition, Kuala Lumpur, 1974; Travelled to India, Nepal, Afghanistan, Iran, Turkey, Greece, Yugoslavia, Italy and West Europe, returned through Syria, Jordon and Lebanon, 1974-1976; Anak Alam 2nd Graphic Exhibition, Penang, 1975; Anak Alam 3rd Graphic Exhibition, T.D.C. Kuala Lumpur; Exhibition in Memory of Zulkifli Dahalan, Lincoln Centre, Kuala Lumpur, 1978; 'Malaysian Art 1965-1978', National Art Gallery, 1978; 'Malaysian Art 1965-1978', Commonwealth Institute, London, 1978; 'The Treatment of the Local Landscape in

Modern Malaysian Art, 1930-1981', National Art Gallery, 1981; ASEAN Mobile Exhibition of Painting and Photographs, 1982; '25 Years of Malaysian Art', National Art Gallery, 1982; Malaysian Art 1957-87, National Art Gallery, 1987.

MOHD. HOESSEIN ENAS, (b. 1924)

Born in Bogor, Indonesia, 1924. Studied under Mr. Koima in Medan, Indonesia and Professor Stanley Green, London.

Exhibitions: 1st Exhibition of Painting, British Council Kuala Lumpur, 1948; participated in various art exhibitions organised by the National Art Gallery, 1950s & 1960s; One-Man Show, Chanil Gallery, London, 1960; Group Exhibition in London & Paris, 1960; Retrospective Exhibition, National Art Gallery, 1965; 'Malaysian Art Touring Europe', 1965-67; 'Malaysian Art Touring Australia & New Zealand, 1966; 'Treatment of the Local Landscape in Modern Malaysian Art 1930-81', National Art Gallery, 1982; '25 Years of Malaysian Art', National Art Gallery, 1982; Exhibition of Paintings Prints and Sculptures from Private Collection, National Art Gallery, 1982; National Invitation Show, National Art Gallery, 1983; National Open Show, National Art Gallery, 1984, 1985; Malaysian Art 1957-87, National Art Gallery, 1987, National Open Show, National Art Gallery, 1988.

SULAIMAN ESA (b. 1941)

Born in Johor Bharu, Johor, 1941. Studied: Hornsey College of Art London, 1962-66; Post-Graduate Course in Print-making at Hornsey College of Art under Michael Rothenstern, 1967; further study in Print-making at the Atelier 17, Paris under S.W. Hayter. Awarded the Italian Government Scholarship to study Costume Design at Academia de Roma, Rome, Italy, 1974-75; Maryland College of Art, Baltimore, U.S.A., 1979-81; participated in Malaysian Art Touring Australia and New Zealand, 1969; 'Salon Malaysia', National Art Gallery, 1969, 'Poets-Painters' Exhibition, Dewan Bahasa and Pustaka, Kuala Lumpur, 1971; 'Personal Choice' National Art Gallery, 1972; Annual Invitation Art Show, National Art Gallery, 1972; 'Malaysian Landscape' National Art Gallery, 1972; 'Man and His World', National Art Gallery, Awarded Major Prize, 1973; 'Mystical Reality', Dewan Bahasa and Pustaka, Kuala Lumpur, 1974; Exhibition of Paintings & Graphic Art, National Art Gallery, 1977; Malaysian Art, 1965-78 Commonwealth Institute, London, 1978; 'Salon Malaysia', National Art Gallery, 1979; Contemporary Asian Art, Fukuoka Art Museum, Japan, 1980; 'Works on Paper', City Hall, Courtyard Galleries, Baltimore, U.S.A., 1981; 'Works on Paper', The Goldman Fine Art Gallery, Washington D.C., U.S.A., 1981; Exhibition of Painting, C. Grimaldis Gallery, Baltimore, U.S.A., 1981; 'Works on Paper', Kanagawa Prefectural Museum, Yokohama, Japan, 1981;

Art Show Hiratsuka City Museum, Japan, 1981; Graduate Exhibition, Maryland Institute of Art, Baltimore, 1981; '25 Years of Malaysian Art', National Art Gallery, 1982; Exhibition of Prints, National Art Gallery, 1982; 'Titian 1' National Museum Art Gallery, Singapore, 1983; National Open Show, National Art Gallery, 1983, 1984; 2nd Asian Art Biennale, Dhaka Bangladesh, 1983; 'Art Works on Paper', Manila, 1983; 'American Experiences: Malaysian Images, American Embassy, Kuala Lumpur, 1984; 'One-Man-Show — 'Towards Unity 1', Australian High Commission, Kuala Lumpur, 1984; One-Man-Show — 'Towards Unity 2', Dewan Bahasa and Pustaka, Kuala Lumpur, 1984, 12 Malaysian Artists Exhibition, Museum of History, Taipei, 1985, 'Fibre Art', Dayabumi, Kuala Lumpur, 1985; Faculty Show, National Art Gallery, 1985; 2nd Contemporary Asian Art Show, Fukuoka Art Museum, Japan, 1985; '86 Seoul Contemporary Asian Art Show, National Museum of Modern Art, Seoul, Korea, 1986; Malaysian Art 1957-87, National Art Gallery, 1987.

YUSOF GHANI (b. 1950)

Born in Pontian, Johore, 29th November 1950.

Studied: George Mason University, Virginia, U.S.A., 1979-81; Catholic University of America, Washington D.C. 1981-83. Awarded Dr. Burt Armada Scholarship, and Most Creative Project, George Mason University, Virginia, 1980. Exhibitions: International Art Exhibition Art Barn Gallery, Washington D.C., 1980; 'Art League' Show, Ferwick Library Gallery, George Mason University, Virginia, 1981; Virginia Panel Exhibition, Grace Gallery, Reston, Virginia, 1981; GMU Student Exhibition, City Hall Gallery, Fairfax, Virginia, 1982; Faculty and Graduate CU Art Barn Gallery, Washington D.C., 1982; M.F.A. Thesis Show, Slavia Regina Gallery, Catholic University of America, Washington D.C., 1983; Invitation (Political Protest) Washington Project for Art Gallery, Washington D.C., 1983; 'Artist Call', Gallerie Intae, Washington D.C., 1984; Two-Person Exhibition, Slavia Regina Gallery, Washington D.C., 1984; One-Man Exhibition, Anton Gallery, Capitol Hill, Washington D.C., 1984; National Open Show, National Art Gallery, 1985-87; 'Citrabudi', Hotel Hilton, Kuala Lumpur, 1985; PNB Art Competition & Exhibition, PNB Building, Kuala Lumpur, 1985, awarded major prize; Faculty Show, National Art Gallery, 1985, 1987; Invitation Show, On-Tai Gallery Kuala Lumpur, 1985; UNICEF 'Art Asia', Sime Darby Building, Kuala Lumpur, 1985; 3rd Asian Art Biennale Dhaka, Bangladesh, 1986; 'Space', National Art Gallery, 1986; 'Dimensions '86', The Store, Kuala Lumpur, 1986; Invitation Exhibition, Bank Negara Kuala Lumpur, 1986; MIA Invitation, MIA Gallery Kuala Lumpur, 1986; 'Senandung Malam' Art Exhibition, SUK Selangor Building, Shah Alam, Selangor, 1986; Malaysian Art 1957-87, National Art Gallery, 1987, National Open Show, National Art Gallery, 1988.

SHAFIE HAJI HASSAN (b. 1958)

Born in Kedah, 1958. Studied: Teachers Training College, Kota Bharu, Kelantan, 1978-79; Specialist Teachers Training Institute, Kuala Lumpur, 1986, participated in National Open Show, National Art Gallery, 1982, 1983, 1985, 1986. 'Young Contemporaries', National Art Gallery, 1983, 1985, 1986; Exhibition of Watercolour Paintings, Le Beaux Art Gallery, Kuala Lumpur, 1983; 'Portrait APS', Gallery 231, Kuala Lumpur, 1984; Exhibition of Watercolour Painting APS, City Hall, Kuala Lumpur, 1984; PNB Art Exhibition, PNB Building, Kuala Lumpur, 1985, awarded 2nd prize in figurative category; 'Self-taught' Artists Exhibition of Paintings, Kuala Lumpur, 1985; 'Konsep-MPIK', Kuala Lumpur, 1986; 'Kuala Lumpur — Kuala Lumpur', City Hall, Kuala Lumpur, 1987; Exhibition of Posters — UNESCO, Federal Hotel, Kuala Lumpur, 1987, awarded Major Prize; Malaysian Art 1957-87, National Art Gallery, 1987.

IBRAHIM HUSSEIN (b. 1936)

Born in Yen, Kedah, 13 March 1936.
Studied: Nanyang Academy of Art Singapore, 1956; Byam Shaw School of Drawing and Painting, London 1959-1963, awarded the Byam Shaw Scholarship (1959-63) and Award of Merit, 1961-63; received Royal Academy Scholarships for further studies at Royal Academy Schools, London, 1963-66; received Fullbright Travelling Scholarship, 1967; and The JDR 3rd Fund Fellowship, 1967-68; attended American Workshop Venice, Italy, 1970.
One-Man Shows: John Whibley Gallery, London, 1963; Galerie Internationale, New York, 1965; A.I.A. Building, Kuala Lumpur, 1966; Chinese Chambers of Commerce Singapore, 1966; Newsweek Gallery 10 Newsweek Building, New York, 1968; Galerie Internationale, New York, 1968; Solidaridad Galleries, Manila, 1969; University of Malaya, 1969, 1975; Dhait Abdullah Al Salam Gallery, Kuwait, 1977; IH Gallery, Kuala Lumpur, 1982; Daruma Art Centre Copenhagen, 1983, Galerie Bortier Brussels, 1983; Galerie Kaleidescoop, Ghent, 1983; 'Jejak Perantau', Universiti Utara Malaysia, 1986; Retrospective National Art Gallery, 1986. Included in the Commonwealth Art Collections, London, 1961; Young Commonwealth Artists, London, 1962; Edinburgh Arts Festival, 1964; Royal Academy Summer Exhibition, London, 1965; 'Grup' Exhibition Kuala Lumpur, 1967; Contemporary World Art Triennale, New Delhi, 1968; Sao Paulo X Biennale, Brazil, 1969; Young Artists Around the World Exhibition, New York, 1969; Malaysian Art Touring Australia & New Zealand, 1969; Poets — Painters Exhibition, Dewan Bahasa & Pustaka, 1970; 'Man and His World' Montreal, Canada, 1970, 35th Venice Biennale, Italy, 1970; Malaysian Art 1932-71, National Art Gallery, 1971; Print Exhibition American Workshop Rome, Milan, Napoli, Italy, 1971; Group Exhibition

Smithsonian Institute, Washington D.C., 1971; 'Personal Choice', National Art Gallery, 1971; Abstract Expressionists of the 60's, National Art Gallery, 1974; Calligraphy Exhibition, University of Malaya, 1975; Acquisition of the 70's, National Art Gallery, 1975; 'My Collections', National Art Gallery, 1976; Malaysian Art 1957-77, National Art Gallery, 1977; Malaysian Art 1965-78, Commonwealth Institute, London, 1978; 4th Triennale India New Delhi, 1978; 1st Exhibition of Asian Art, Bahrain, 1980; 'The Treatment of Local Landscape in Modern Malaysian Art 1930-81', National Art Gallery, 1982; Exhibition of Prints, National Art Gallery, 1982; Exhibition of Paintings, Prints & Sculpture from Private Collection, National Art Gallery, 1982; '25 Years of Malaysian Art', National Art Gallery, 1982; 'National Art Gallery 1958-1983', National Art Gallery, 1983; 'American Experiences; Malaysian Images', American Embassy, Kuala Lumpur, 1984; Exhibition of Painting & Calligraphy National Art Gallery, 1984; XVIII Prix International D'Art Contemporain de Monte Carlo, 1984; Singapore Arts Festival, National Museum Art Gallery, Singapore, 1986; Malaysian Art 1957-87, National Art Gallery, 1987.

KHALIL IBRAHIM (b. 1934)

Born in Kubang Krian, Kelantan, 1934. Studied: St. Martin's School of Art, London, 1960-64; Post-Graduate St. Martin's School of Art, London, 1964-65.

One-Man Shows: Samat Gallery, Kuala Lumpur, 1968, 1969, 1970, 1972, 1974, 1976; Balai Budaya Jakarta, 1970; Gallery of Fine Art, Singapore, 1970; Galerie Delafontain, Geneva, Switzerland, 1971; Raya Gallery, Kew, Victoria, Australia, 1975, 1976; Asian Art Museum, University of Malaya, Kuala Lumpur, 1975; La Pagode, (Zyma), Nyon, Switzerland, 1978; Hotel Equatorial, Kuala Lumpur, 1983. Included in: Malaysian Art Touring Australia & New Zealand, 1969-1971; 10th Sao Paulo Biennale, Brazil, 1969; 'Man & His World', Montreal, Canada, 1970; Expo '70, Osaka, Japan, 1970; Nine Artists, 'Kunstgilde', Bern, Switzerland, 1974; Three Malaysian Artists, Kew, Victoria, Australia, 1974; 'Anak Alam', Penang State Museum, 1975; Moomba Festival, Melbourne, Australia, 1976, 1977; Group Exhibition, Wupperfurth, Huckeswagen, West Germany, 1977; Malaysian Art: 1965-1978, Commonwealth Institute, London, 1978; 'Salon Malaysia', National Art Gallery, 1979; Contemporary Asian Art Show, Fukuoka Art Museum, Fukuoka, Japan, 1980; Exhibition of Contemporary Art, Singapore Festival of Art, National Museum Art Gallery Singapore, 1980; ASEAN Mobile Art Exhibition, 1981, 1984; National Open Show, National Art Gallery, 1982, 1984, 1985, 1986; Joint Exhibition with Yeoh Jin Leng at the Australian High Commission, Kuala Lumpur, 1984; ASPACAE Exhibition, On-Tai Gallery, Kuala Lumpur, 1985; 12 Malaysian Artists Exhibition, National Museum of History, Taipei, 1985; Watercolour Society

'85, Kuala Lumpur, 1985; Exhibition of Painting Endau/Rompin Heritage, National Art Gallery, 1985; Contemporary Malaysian/British Art, National Art Gallery, 1986; Malaysian Art 1957-87, National Art Gallery, 1987.

SYED AHMAD JAMAL (b. 1929)

Born in Muar, Johor, 19 September 1929. Studied: Chelsea School of Art, London, 1951-55; Institute of Education, London University, 1955-56; School of the Art Institute, Chicago, U.S.A., 1962-64; University of Hawaii, Honolulu, 1973-74; Harvard University, Cambridge, Massachusetts, 1974 (Summer).

One-Man Shows: Kuala Lumpur, 1960; Singapore, 1961, Kuala Lumpur, 1965; 'Lela Mayang Suite', Kuala Lumpur, 1968; Asian Art Museum, University of Malaya, Kuala Lumpur, 1975; Retrospective Exhibition, National Art Gallery, 1975. Participated in: Young Artists' Exhibition, London, 1954-55; Won several awards namely 'Summer Competition', Chelsea School of Art, London, First Prize; Sketch Club Exhibition, Chelsea School of Art, First Prize — Portrait 1954. Included in 3rd Annual Commonwealth Artists' Exhibition, London, 1955; South-east Asian Art Exhibition, Manila, Philippines, 1957; 4th International Contemporary Art Exhibition, New Delhi, 1961; Federation Art Competition, Kuala Lumpur, 1962, awarded Major Prize; First International Art Exhibition, Saigon, 1962; 'Commonwealth Art Today', London, 1962/63; 'Mother & Child' Art Competition, Kuala Lumpur, 1963; awarded 2nd Prize; SEAP Games Art Exhibition, Kuala Lumpur, 1965; Waratah Spring Festival, Sydney, 1965; Malaysian Art Exhibition, Commonwealth Arts Festival, Glasgow, Scotland, 1965; Malaysian Art Touring Europe, 1965-67; Contemporary Malaysian Paintings, India, 1966; 'Grup' Show, Gallery Ampang, Kuala Lumpur, 1967; 1st Triennale of Contemporary World Art, New Delhi, 1968; 'Salon Malaysia', National Art Gallery, 1968; 'Malaysian Art' Touring Australia & New Zealand, 1969; 10th Sao Paulo Biennale, Brazil, 1969; 'Asian Countries in Contemporary Art', Tokyo, 1969; 'Expo '70', Osaka, Japan, 1970; 'Man and His World', Montreal, Canada, 1970; 'Poets and Painters' Exhibition, Dewan Bahasa & Pustaka, Kuala Lumpur, 1970; awarded First Prize, Mural for Bank Negara, 1970; 'Malaysian Art 1935-71', National Art Gallery, 1971; International Society of Plastic and Visual Exhibition', Kuala Lumpur, 1972; 'Personal Choice', National Art Gallery, 1972; Abstract Expressionists of the 60s, National Art Gallery, 1974; 'Modern Sculpture in Malaysia', National Art Gallery, 1976; North Malaysian Week Festival, Adelaide, Australia, 1977; 'Plastic Art in Malaysian, 1957-77', National Art Gallery, 1976; 4th Triennale of Contemporary World Art, New Delhi, 1978; 'Malaysian Art 1965-78', Commonwealth Institute, London, 1978; 'Esso Collection', Kuala Lumpur, 1979; ASEAN Mobile Exhibition of Painting and Photographs, 1980, 1981; Contemporary Asian Art Show, Fukuoka Art Museum, Japan, 1980; Premier

Show, Malaysian Artists Association, University of Malaya, 1981; 1st Exhibition of Asian Art, Bahrain, 1981; 'The Treatment of Local Landscape in Modern Malaysian Art, 1930-81', National Art Gallery, 1982; 25 Years of Malaysian Art, National Art Gallery, 1982; Exhibition of Paintings, Prints & Sculpture from Private Collection, National Art Gallery, 1982; 'Titian 1', National Museum Art Gallery Singapore, 1983; 'The Question of Palestine', City Hall, Kuala Lumpur, 1983; National Invitation Show, National Art Gallery, 1983; 'National Art Gallery 1958-1983', National Art Gallery, 1983; Exhibition of Paintings & Calligraphy, National Art Gallery, 1984; 'Fibre Art', Kuala Lumpur Arts Festival, 1985; Exhibition of Painting & Photographs — Malaysian Heritage Endau/Rompin, National Art Gallery, 1985; National Open Show, National Art Gallery, 1985, 1986, 1987; 'Space', National Art Gallery, 1986; Contemporary Malaysian/British Art, National Art Gallery, 1986; International Exhibition of Art Gallery & Museum Posters, Richmond Art Gallery, Canada, 1987; Malaysian Art 1957-87, National Art Gallery, 1987; National Open Show, National Art Gallery, 1988.

SUI-HO KHOO (b. 1939)

Born in Baling, Kedah, 1939. Studied: Nanyang Academy of Art, Singapore, 1959-61; Pratt Graphic Centre New York, J.D.R. III Fund Fellowship, 1974. One-Man Shows: British Council, Kuala Lumpur, 1966; A.I.A. Building, Kuala Lumpur, 1967; Penang State Museum, 1967; Galeri Trio, Bangkok, 1968; Leland Gallery, Taipei, 1969; Alpha Singapore, 1972, 1974, 1976; Mekpayab Art Centre, Bangkok, 1973; Samat Gallery, Kuala Lumpur, 1974; Raya Gallery, Melbourne, Australia, 1978, 1980; Gallery Newton, Adelaide, Australia, 1978; Raya Gallery, Singapore; Alliance Francaise, Singapore, 1979; Art House Gallery, Kuala Lumpur, 1980; International Monetary Fund, Washington D.C., 1981; Lynn Kottler Galleries, New York, 1981; Prince Kuhio Federal Building, Honolulu, 1982.

Included in Malaysian Art Touring India, 1963; Contemporary Asian Art, Hong Kong, 1965; 5th International Contemporary Art Exhibition, New Delhi, 1966; Malaysian Art Touring Europe, 1965/66; 1st Indian Triennale, New Delhi, 1968; Young Artists Asia, Tokyo, 1969; 10th Sao Paulo Biennial, Brazil, 1969; Malaysian Art Touring Australia & New Zealand, 1969; National Invitation Show, National Art Gallery, 1972; 'Man & His World', National Art Gallery, 1972; Malaysian Art 1965-78, Commonwealth Institute, London, 1978; Group Show, Penang State Museum, 1979; 'Retrospective Exhibition of the Nanyang Artists', National Art Gallery, 1979; Premier Show, Malaysian Artists Association, University of Malaya, 1981; ASEAN Mobile Exhibition of Paintings & Photography, 1981; 'The Treatment of the Local Landscape in Modern Malaysian Art, 1930-81', National Art Gallery, 1981/82; Exhibition of Paintings, Prints & Sculpture from Private

Collection, National Art Gallery, 1982, '25 Years of Malaysian Art', National Art Gallery, 1982; Participated in the UTARA Group Exhibition from 1977-86; Malaysian Art 1957-87, National Art Gallery, 1987, UTARA Group Exhibition, Australian High Commission Kuala Lumpur, 1987.

KIAN SENG, LEE (b. 1948)

Born in Kelang, Selangor 1948. Studied Ukiyo-e (Oriental Art) under the guidance of Nakamura Denzaburo (Tokyo Research Institute of Cultural Properties) 1969-1972; Tokyo Hanga Kenkyusho (Tokyo Institute of Print-making) 1971-1972; Studied Yuzenzomei (Japanese traditional dyeing art) in Kanazawa under the guidance of Yusui Toku, 1974; Tokyo National University of Arts and Music (Post-graduate) Specialised in dyeing art, printmaking and modern technological art, 1976-1977.

One-Man exhibitions; A.I.A. Building, Kuala Lumpur, sponsored by the Arts Council of Malaysia, 1966; Seremban, sponsored by the Negeri Sembilan Arts Society, 1967; Galeri II, Kuala Lumpur, 1967; Samat Gallery, Kuala Lumpur, 1968, 1969, 1970, 1972; Trio Gallery, Bangkok, 1968; Gallery Nippon, Japan, 1969; American Club, Japan, 1969, Galaxy Gallery, Kuala Lumpur, 1971; Ginporo Gallery, presented by the UNESCO Art Education League, Japan, 1974; Shunju-kan Gallery, Japan, 1975. Included in the '6th Young Artists Exhibition', Arts Council of Malaysia, 1962; 9th Malaysian Artist Annual Exhibition, Arts Council of Malaysia, 1963; 'Joy of Living' National Art Competition, Arts Council of Malaysia, awarded 3rd prize, 1964; Annual National Exhibition, National Art Gallery, 1965-1971; Waratah Spring Arts Festival, Australia, 1966; 10th Young Artist Exhibition, Arts Council of Malaysia, 1966; 1st Triennale of Contemporary of World Art, New Delhi, India, 1967; Malaysian Art Touring Australia and New Zealand, 1969; Sao Paulo X Biennale, Brazil, 1969; 'Salon Malaysia', National Art Gallery, 1969, awarded 3rd prize in sculpture, 3rd prize in mixed media & honourable mention in batik; 'Malaysian Art 'Expo 70' Osaka, Japan, 1970; 'Personal Choice', National Art Gallery, 1971; Malaysian Landscape Exhibition & Competition, National Art Gallery, awarded Major Prize, 1972; 'Man and His World', National Art Gallery, 1973, awarded Minor Prize; 'The Young Contemporary', National Art Gallery, 1975, received best artist award; 'Tokyo Ten', Tokyo Metropolitan Museum, Tokyo, 1976; 'A View of Modern Sculpture in Malaysia', National Art Gallery, 1976; National Competition of Painting & Graphic, National Art Gallery, 1977, received Major Awards in Painting and Printmaking; 'Malaysian Art 1957-1977', National Art Gallery, 1977; 4th Triennale of Contemporary World Art, New Delhi, 1978; 2nd Western Pacific Print Biennale, Australia, 1978; Malaysian Art: 1965-1978, Commonwealth Institute, London, 1978; Tokyo Print Biennale, National Museum of Modern Art Tokyo, Sapporo Art Museum, Kyoto Art Museum, 1979; Contemporary Asian Art', Fukuoka Art Museum, Japan, 1980; ASEAN

Mobile Exhibition of Paintings & Photographs, 1980, 1982, 1983, 1984; Exhibition of Prints, National Art Gallery, 1982; 'Treatment of Local Landscape in Modern Malaysian Art 1930-1981, National Art Gallery, 1982; Exhibition of Paintings, Prints & Sculpture from Private Collection, National Art Gallery, 1982; '25 Years of Malaysian Art', National Art Gallery, 1982; National Open Show, National Art Gallery, 1982; 'Titian 1', National Museum Art Gallery Singapore, 1983; National Invitation Show, National Art Gallery, 1983; Malaysia's National representative at the ASEAN Sculpture Symposium, Jakarta, 1984; ASPACAE '85, On-Tai Gallery, Kuala Lumpur, 1985; 3rd Asian Art Biennale, Dhaka Bangladesh, 1986; Malaysian Art 1957-87, National Art Gallery, 1987; National Open Show, National Art Gallery, 1988.

ENG HOOI, LIM (b. 1943)

Born in Penang,, 1939. Studied: Ruskin School of Drawing and Fine Arts, University of Oxford, U.K., 1964-66; St. Benet's Hall, University of Oxford, 1966-69; awarded Leverhulme Scholarship for further studies at Byam Shaw School of Drawing and Painting, London, 1969-72; School of Visual Arts, New York, received The JDR 3rd Fund Fellowship, 1978. Participated in various local exhibitions in Penang, 1958-64; 'Six Young Artists', Penang, 1959; One-Man Show, Penang, 1963, 1964; Ruskin School of Drawing, Oxford, 1966; Byam Shaw School of Drawing & Painting London, 1972; Art Master, Brooke House School, London, 1972; included in various local shows, Penang, 1973-76; One-Man Show, University of Science Malaysia, Penang, 1975; 4th International Art Exhibition, Singapore, 1975; 6th International Art Exhibition, Singapore, 1977; National Open Art and Print Competition, National Art Gallery, 1977, awarded Minor Prize; 'Malaysian Art 1965-78', Commonwealth Institute, London, 1978; 'Salon Malaysia' National Art Gallery, 1979; 8th International Art Exhibition, Alpha Gallery Singapore, 1979; ASEAN Mobile Exhibition, 1981; '25 Years of Malaysian Art', National Art Gallery, 1982; Sculpture Competition and Exhibition, Penang, 1983; National Open Show, National Art Gallery, 1984; Exhibition of Painting, Arts Center, University of Science Malaysia, Penang, 1984; Penang Watercolour '85, Penang Watercolour Society, 1985; PNB Art Exhibition & Competition, PNB Building, Kuala Lumpur, awarded a minor prize, 1985; Exhibition of Painting & Photographs Malaysian Heritage Endau/Rompin, National Art Gallery, 1985; National Open Show, National Art Gallery, 1986; Malaysian Art 1957-87, National Art Gallery, 1987.

KHOON HOCK, LIM (TOYA)

Born in Penang. Self-taught artist, became an apprentice of his former art teacher Chuah Thean Teng for six months. One-Man Shows: Penang, 1965; Bangkok, 1969, 1970, 1973; Australia, 1971; Indonesia, 1972;

Geneva, 1974, New York 1975, 1976; Penang State Museum, 1983. Participated in Local Artist Exhibition, Penang, 1966; National Open Show, National Art Gallery, Kuala Lumpur, 1968.

THIEN SHIH, LONG (b. 1946)

Born in Klang, Selangor, 1946. Studied drawing with the Wednesday Art Group Kuala Lumpur, 1959-64; Awarded scholarship by French Ministry of Culture for further studies in Paris with William Hayter at Atelier 17, Paris, 1966-68; Studied Lithography with Prof. Dayez at L'Ecole Nationale Superieure des Beaux-Art, Paris, 1967-69; Royal College of Art, London, 1969-71. One-Man Shows: Arts Council Kuala Lumpur, 1965; Samat Gallery, Kuala Lumpur, 1968; Included in: Salon D'Automme, Museum of Modern Art, Paris, 1966; "Oriental Theme", Grosvenor Gallery, London, 1967; Atelier 17 Group Shows in Los Angeles, Montreal, Melbourne, 1967; 51st Society of Canadian Etchers & Engravers Annual Exhibition, 1967; 1st British Prints Biennale, Bradford, England, 1968; 23rd Salon des Realities Nouvelles, Paris, 1968; Moderne Drucjgrahik Aus Asien, Germany, 1968; Triennale International di Xilografic, Capri, Italy, 1969; 2nd British International Prints Biennale, Bradford, 1970; Mostra International di Xilografic, Capri, 1971; 7th International Biennale Exhibition of Prints, Tokyo, Japan, 1971; 9th Biennale de Paris, 1971; Young Artists International, New York, 1971; Biennale de Sao Paulo, Brazil, 1971; Exposicion International de la Xilografia Contempranea Madrid, Spain, 1972; 3rd British International Print Biennale, Bradford, 1972; 4th International Biennale of Prints, Cracow, Poland, 1972; Contemporary Prints by Chinese Artists, Hong Kong, 1973; 3rd Biennale Internationale de L'Estampe, Paris, 1973; 9th International Biennale of Prints, Tokyo, 1975; 11th International Biennale of Prints, Tokyo, 1979; 12 Malaysian Artists Exhibition, National Museum of History, Taipei, 1985; National Open Show, National Art Gallery, 1985, 86; 'Space' National Art Gallery, 1986; Contemporary Malaysian/British Art, National Art Gallery, 1986; Malaysian Art 1957-1987, National Art Gallery 1987.

ISMAIL MOHD ZAIN (b. 1930)

Born in Alor Star, Kedah, May 6, 1930. Studied: Malayan Teachers Training College, Kirkby, United Kingdom, 1951-53; Ravensbourne College of Art, U.K., 1961-64; Slade School of Art, London University, 1964-66. Included in: National Exhibitions at the National Art Gallery, 1967-71; 10th Biennale, Sao Paulo, Brazil, 1969; 5th Biennale Young Artists, Tokyo, 1969; Travelling Exhibition of Malaysian Art to Australia and New Zealand, 1969; 'Man & His World', Montreal, Canada, 1970; 'Poets & Painters Exhibition, Dewan Bahasa & Pustaka, Kuala Lumpur, 1970, 1971; International Society of Plastic & Audio-visual Art Exhibition, Kuala Lumpur, 1972; ASEAN Mobile Exhibition, 1974, 1981, 1983, Expressionist and Abstract Expres-

sionist Artists of the Sixties, National Art Gallery, 1974; Awarded 'Kesatria Mangku Negara' by Malaysian Government, 1975; 'Malaysian Art: 1959-78', National Art Gallery, 1977; Malaysian Art: 1965-78, Commonwealth Institute, London, 1978; 25 Years of Malaysian Art, National Art Gallery, 1982; National Invitation Exhibition, National Art Gallery, 1983; Group Exhibition, Museum & Gallery University of Science Malaysia, 1984; Exhibition of Painting & Calligraphy, National Art Gallery, 1984; National Open Show, National Art Gallery, 1985, 1986; Contemporary Malaysian/British Exhibition, National Art Gallery, 1986; Malaysian Art 1957-87, National Art Gallery, 1987.

ABDUL LATIFF MOHIDIN (b. 1938)

Born in Seremban Negeri Sembilan, 1938. Studied: Academy of Fine Arts, Berlin, 1960-64; Atelier La Courriere, Paris, 1968; Pratt Graphic Centre New York, 1970. Since 1951, Abdul Latiff has held 25 one-man shows and has participated in numerous international art exhibitions, among them: 'Malaysian Art' Touring Europe, 1965-67; Touring Art Exhibition to Thailand, Laos, Cambodia and Indonesia, 1966-67; 1st Triennial of Contemporary World Art, New Delhi, India, 1968; 'Salon Malaysia' National Art Gallery, awarded 2nd prize, graphic prints, Hon. Mention other media, 1968; 'Malaysian Art Touring Australia & New Zealand, 1969; 10th Sao Paulo Biennial, Brazil, 1969; The International Biennial of Prints, Tokyo, Japan, 1971; Retrospective Exhibition, National Art Gallery, 1973; The Abstract Expressionists of the 60's, National Art Gallery, 1975; 'Malaysian Art 1957-77', National Art Gallery, 1977; 'Malaysian Art 1965-78', Commonwealth Institute, London, 1978; Exhibition of Paintings, Prints & Sculptures from Private Collection, National Art Gallery, 1982; The Treatment of the Local Landscape in Modern Malaysian Art, 1930-1981, National Art Gallery, 1982; 25 Years of Malaysian Art, National Art Gallery, 1982; Exhibition of Prints, National Art Gallery, 1982; Represented Malaysia in the 4th ASEAN Square Sculpture Symposium in Brunei Darussalam, 1985; Malaysian Art 1957-87, National Art Gallery, 1987; One-Man Show, Malayan Banking Kuala Lumpur, 1988.

BUAN CHER, NG (b. 1946)

Born in Kuala Lumpur, 1946. Studied: National Academy of Arts, Taiwan, 1966-69; Chelsea School of Art London, LDAD Mural Design, 1975-78; Post-Diploma Printmaking Chelsea School of Art, 1978-79; Advanced Stained Glass, Central School of Art London, 1979-80. Solo exhibitions: Kuala Lumpur, 1975; Commonwealth Institute London, 1980. Participated in: Royal Overseas League Art Exhibition, London, 1977; Three Artists Art Exhibition, Commonwealth Institute, 1978; Chelsea Art Society's 31st Exhibition, London, 1978; City of Westminster Arts Council's Exhibition,

London, 1978; Kensington & Chelsea Artist Exhibition, London, 1978; Fine Art Joint Exhibition, National Museum of History & Kwa Kang Museum, Taipei, 1983; International Contemporary Ink-Painting Association's Exhibition, Seoul, 1983; 8th British International Print Biennale, Bradford, 1984; National Open Show, National Art Gallery, 1984-86; An Exhibition of Abstract Paintings, Fine Art Museum, Taipei, 1984; ASPACAE '85 International Art Exhibition, On-Tai Gallery, Kuala Lumpur, 1985; ICIPA '85 International Art Exhibition, 1985; KIS '85 Kunsan International Modern Art Exhibition, Republic of Korea, 1985; 11th International Independent Exhibition of Prints, Kanagawa, Japan, 1985; 9th British International Print Biennale, England, 1986; 3rd Asian Art Biennale, Dhaka, Bangladesh, 1986; Modern Asian Biennale, Dhaka, Bangladesh, 1986; Modern Asian Ink & Colour Painting Exhibition, Art Center, The Korean Culture and Arts Foundation, Seoul, 1986; Contemporary Malaysian/British Art, National Art Gallery,. 1986; 'Space', National Art Gallery, 1986; 1st International Biennale of Print, Campinas, Sao Paulo, Brazil, 1987; Inter-grafik '87, West Berlin, 1987; Malaysian Art 1957-87, National Art Gallery, 1987; National Open Show, National Art Gallery, 1988.

AMRON OMAR (b. 1957)

Born in Alor Star, Kedah, 1957. Studied at MARA Institute of Technology, Malaysia, 1976-1980. Participated in Contemporary Asian Art Show, Fukuoka Art Museum, Japan, 1980, ASEAN Mobile Exhibition of Paintings & Photographs, 1981; 'Young Contemporaries', National Art Gallery, awarded Minor Prize, 1982; '25 Years of Malaysian Art', National Art Gallery, 1982; National Open Show, National Art Gallery, 1984, 1985; Portrait Exhibition, Gallery 231, Kuala Lumpur, 1984; APS Water Colour Exhibition, Kuala Lumpur, 1984; 4th ASEAN Mobile Exhibition of Paintings & Photographs, 1985; Sime Darby Art Asia Exhibition, Kuala Lumpur won Silver Award, 1985; 'Estetika XI' Exhibition, Kuala Lumpur, 1985; Malaysian Art 1957-87, National Art Gallery, 1987.

FAUZAN OMAR (b. 1951)

Born in Kelantan, 1951. Studied: MARA Institute of Technology, 1969-1974; Maryland Institute College of Art, Baltimore, U.S.A., 1982-1984. Participated in 'Faculty Show', British Council, Kuala Lumpur, 1979; Contemporary Asian Art Show, Fukuoka Art Museum, Japan, 1980; ASEAN Exhibition of Paintings & Photographs, 1981; the 'Young Contemporary' National Art Gallery, 1981, 1982; won Minor award, 1982; 5th Triennale, India, New Delhi, 1982; National Open Show, National Art Gallery, 1982, 1986, 1987; 1st Year MFA Exhibition, Mayeroff Gallery, MICA Baltimore, U.S.A., 1983; 'Works on paper', Baltimore Museum of Art, Maryland, U.S.A., 1983; 'Paper an Art Form', Dundalk Community College, Dundalk, Maryland,

U.S.A., 1983; 2nd Year MFA Show, Mayeroff Gallery, MICA Baltimore, U.S.A., 1984; MFA Show Tesis Gallery, MICA Baltimore, U.S.A., 1984; PNB Art Exhibition, PNB Building, Kuala Lumpur, 1985; won Major award; Saujana Art Exhibition, City Hall, Kuala Lumpur, 1985; Invitation Show, On-Tai Gallery, Kuala Lumpur, 1985; 'Perdana II' Exhibition, Australian High Commission, Kuala Lumpur, 1986; 'Space', National Art Gallery, 1986; Faculty Show, National Art Gallery, 1987; Malaysian Art 1957-87, National Art Gallery, 1987, National Open Show, National Art Gallery, 1988.

AZAHARI KHALID OSMAN (b. 1951)

Born in Kuala Lumpur in 1951. Studied at the Werkkunstschule, Wuppertal, West Germany, 1972-73, London College of Printing, 1974; Academy of Fine Arts, Bologna, Italy, 1975.

Participated in Portomaggiore Spring Art Competition, Italy, 1977; 'R78' International Exhibition, Modigliana, Italy, 1978; House of Lubian Art Exhibition, Italy, 1979; Group Exhibition, Gallery Six, Kuala Lumpur, 1981; National Open Show, National Art Gallery, 1982, 1984; 'The Question of Palestine', City Hall, Kuala Lumpur, 1983; 2nd Asian Art Biennale Dhaka, Bangladesh, 1983; 'Music and Art', British Council, Kuala Lumpur, 1983; One-Man Show, Equatorial Hotel, Kuala Lumpur, 1984; Third ASEAN Exhibition of Paintings and Photography, Singapore, Kuala Lumpur, Manila, Jakarta, Bangkok, 1984; Malaysian Art 1957-1987, National Art Gallery 1987.

Appointed resident artist of Public Bank Berhad, Kuala Lumpur, 1985-1986.

REDZA PIYADASA (b. 1939)

Born in Kuantan, Pahang, 1939. Studied: Malayan Teachers College, Brinsford Lodge, Wolverhampton, England, 1958-59; Specialist Teachers Training Institute, Kuala Lumpur, 1962; Hornsey College of Art, London, 1963-67; University of Hawaii, Honolulu; East-West Centre, Honolulu, Hawaii, 1975-77.

Participated in Group Exhibition, London, 1967; 'Salon Malaysia', National Art Gallery, 1969; 'Poets & Painters' Exhibition, Dewan Bahasa & Pustaka, Kuala Lumpur, 1970; 'Experimental '70, Kuala Lumpur, 1970; 'Malaysian Art 1932-1971', National Art Gallery, 1971; 'Personal Choice', National Art Gallery, 1972; ASEAN Exhibition, Singapore, 1973; 'Malaysian Landscape Exhibition & Competition, National Art Gallery, awarded Major Prize, 1972; 'Malaysian Art 1956-73' National Art Gallery, 1973; ASEAN Mobile Exhibition of Paintings and Photographs, 1980, 1981, 1983, 1984; 'Towards a Mystical Reality', Dewan Bahasa & Pustaka, Kuala Lumpur, 1974; Modern Malaysian Sculpture, National Art Gallery, 1976; Group Exhibition, Honolulu, Hawaii, 1976, 1977; One-Man Show, University of Hawaii, Honolulu, 1977; 'Malaysian Art 1965-78', Commonwealth Institute,

London, 1978; One-Man Show, Lincoln Centre, Kuala Lumpur, 1978; 'Salon Malaysia', National Art Gallery, 1979, awarded Minor Prize; Contemporary Asian Art Show, Fukuoka Art Museum, Japan, 1980; Premier Exhibition Malaysian Artists Association, University of Malaya, 1981; 'Treatment of the Local Landscape in Modern Malaysian Art, ·1930-81', National Art Gallery, 1982; 'Geraktara', Penang State Museum, 1982; '25 Years of Malaysian Art', National Art Gallery, 1982; awarded Ahli Mangku Negara (A.M.N.) by Federal Government, 1982; 'Titian 1', National Museum Art Gallery Singapore, 1983; National Invitation Show, National Art Gallery, 1983; Group Exhibition, U.S.M. Museum & Art Gallery, Penang, 1984; Saujana Art Exhibition, City Hall, Kuala Lumpur, 1984; Contemporary Malaysian/British Art, National Art Gallery, 1986; received the Australian Government Cultural Award, 1987; Malaysian Art 1957-87, National Art Gallery, Kuala Lumpur, 1987, 'Historical Heritage' One-Man Show, Pan Pacific Hotel, Kuala Lumpur, 1987

ANNUAR RASHID (b. 1958)

Born in Alor Star, Kedah, 1958. Studied: MARA Institute of Technology, Malaysia, 1975-79. Awarded Starr Fellowship Asian Cultural Council — a travel grant to the United State, 1986.

Participated in the 'Young Contemporaries', National Art Gallery, 1976; National Open Show, National Art Gallery, 1977; Art Exhibition from Local Art Institutions, National Art Gallery, 1978; One-Man Show, Penang State Museum, 1978; One-Man Show, Alpha Gallery Singapore, 1979; 'United World College Art Festival' Singapore, 1979; One-Man Show, JARD, Johor Bharu, 1979; Salon Malaysia, National Art Gallery, awarded Minor Prize, 1979; Group Exhibition, Anak Alam, Kuala Lumpur, 1980; Contemporary Asian Art Show, Fukuoka Art Museum, Japan, 1980; Group Exhibition, Anak Alam, Dewan Bahasa & Pustaka, Kuala Lumpur, 1981; 'Treatment of Local Landscape in Contemporary Malaysian Art, 1930-81', National Art Gallery, 1981; '25 Years of Malaysian Art', National Art Gallery, 1982; One-Man Show, Centro Artistico, Argentino, Ferara, Italy, 1982; One-Man Show, Holmes Place Centre, London, 1982; Group Exhibition, Anak Alam, Aliance Francais Kuala Lumpur, 1982; One-Man Show, Equatorial Hotel, 1983; ASEAN Mobile Exhibition of Painting & Photographs, 1983; Invitation by the Council of Culture and Socialist Education of Romania as Visiting Artist, 1984; One-Man Show, Sala Cultural E Scientifik, Roman Soviet Bucharest, Romania, 1984; Group Exhibition, Sierra de Argenta, Italy, 1984; Visited Switzerland on a Grant by the Official Swiss Cultural Organisation (STISTUNG PRO Halvetcia) 1984; awarded a fellowship by the French Government to work in Paris, 1984; Group Exhibition, Gallery Bernanos, Paris, 1984; participated in the International Arts Festival at the International Artists Colony of Prilep, Rep. of Macedonia, Yugoslavia,

1985; Guest Artist at Josip Broz Tito Gallery for the Non-Aligned nations, Titograd, Yugoslavia, 1985; 2nd Non-Aligned Summit Art Show, Harate, Zimbabwe, 1985; Malaysian Art 1957-87, National Art Gallery, 1987.

NIRMALA SHANMUGHALINGAM (b. 1941)

Born in Penang, 1941. Studied under Hoessein Enas in Kuala Lumpur, 1962; Corcoran School of Art, Washington D.C., 1966-67; Fogg Museum of Art — Harvard University Extension Course, 1970-71; Education Centre, Cambridge, Massachusettes, 1970-71; Obtained BSC. (Hons) from Oxford Polytechnic, Oxford, 1975-78.

Solo exhibition: Dewan Bahasa & Pustaka, Kuala Lumpur, 1981. Included in: International Exhibition of Child Art, Haque Holland, 1957; Annual Exhibition, National Art Gallery 1964; Corcoran School of Art, Washington D.C., 1967; 'Salon Malaysia', National Art Gallery, 1968; 12th National Art Exhibition, Kuala Lumpur, 1969; Malaysian Landscape Exhibition, National Art Gallery, 1972; 'Man & His World' Exhibition, National Art Gallery, awarded Major Prize, 1973; ASEAN Mobile Exhibition of Paintings, Graphics and Photographs, 1981, 1983, 1985; 5th Triennale India, New Delhi, 1982; '25 Years of Malaysian Art', National Art Gallery, 1982; National Invitation Show, National Art Gallery, 1983; 'American Experiences/Malaysian Images', US Embassy, Kuala Lumpur, 1984; Saujana Exhibition, City Hall, Kuala Lumpur, 1984; Contemporary Malaysian/ British Art, National Art Gallery, 1986; Malaysian Art 1957-87, National Art Gallery, 1987.

SHARIFAH FATIMAH SYED ZUBIR (b. 1948)

Born in Alor Star, Kedah, 1948. Studied: MARA Institute of Technology, 1967-71, Reading University, England, 1973-76, awarded University Prize, 1976; awarded the JDR III Fund Fellowship for further studies at Pratt Institute, New York, 1976-78, awarded Pratt Studio Scholar award, Pratt Institute, 1977; awarded British Council fellowship 1987.

One-Man Shows: Alpha Gallery, Singapore, 1972; Penang State Museum, 1978; Loke House, Kuala Lumpur, 1980; Australian High Commission, Kuala Lumpur, 1983; Gallery 231, Kuala Lumpur, 1984; Alpha Gallery Singapore, 1985; Galeri Citra, Kuala Lumpur, 1987.

Participated in: Group Exhibition, Galeri II, Kuala Lumpur, 1968; 'Salon Malaysia', National Art Gallery, 1969; 'Talent & Hope', Samat Gallery, Kuala Lumpur, 1970; 'Poets & Painters' Exhibition, Dewan Bahasa & Pustaka, Kuala Lumpur, 1971; 'Malaysian Landscape', National Art Gallery, awarded Minor Prize, 1972; National Invitation Show, National Art Gallery, 1973, 1983; Winsor & Newton Exhibition of Paintings, Reading Gallery, England, 1975; Stowell Trophy Exhibition of Painting, Diploma Galleries, Royal Academy of Arts, London, 1976; Invitational Drawing Show, Gallery 55

Mercer, New York, 1976; Group Exhibition of Prints, Glassboro State College New Jersey & Bloomsburg State College, Pennsylavania, U.S.A., 1977; Artists 77 International Art Exhibition, Union Carbide Building, New York, 1977; Group Exhibition, Winners of the Studio Scholar Awards, Institute Gallery, Brooklyn, New York, 1977; College Art Association MFA Candidate Drawing Exhibition, North Eastern States, Parson School of Design, New York, 1978; 'Salon Malaysia', National Art Gallery, awarded Major Prize, 1979; UTARA '80 Dewan Sri Pinang, Penang, 1980; Contemporary Asian Art Show, Fukuoka Art Museum, Japan, 1980; the 'Young Contemporaries', National Art Gallery, awarded Minor Prize, 1981; ASEAN Mobile Exhibition of Paintings & Photographs, 1981, 1984; Premier Show, Malaysian Artist Association, University of Malaya, 1981; International Print Show, National Museum Art Gallery Singapore, 1982; Exhibition of Prints, National Art Gallery, 1982; Exhibition of Paintings, Prints & Sculptures from Private Collection, National Art Gallery, 1982; Exhibition of Paintings by Malaysian Women Artists, University of Malaya, 1982; '25 Years of Malaysian Art', National Art Gallery, 1982; 'Titian 1', National Musem Art Gallery Singapore, 1983; National Open Show, National Art Gallery, 1983, 1984, 1985; 2nd Asian Art Biennale Dhaka, Bangladesh, Malaysia's representative to Dhaka, 1983; participated in the ASEAN Exchange of Museum Curators of Art, 1983; American Experiences: Malaysian Images, American Embassy, Kuala Lumpur, 1984; Exhibition of Paintings and Calligraphy, National Art Gallery, 1984; 2 Man Show Bandar Seri Begawan, Brunei Darussalam, 1984; 12 Malaysian Painters, Museum of History, Taipei, 1985; a performance Program & Exhibition presented by Grantees of the Asian Cultural Council, Nautilus Club, Hong Kong, 1985; ASPACAE '85, Gallery On-Tai, Kuala Lumpur, 1985; UTARA '85, Penang State Museum, 1985; Exhibition of Paintings & Photographs Malaysian Heritage Endau/Rompin National Art Gallery, 1985; 'Space' National Art Gallery, 1986; Contemporary Malaysian/British Art, National Art Gallery, 1986; Invitation Show, Galeri MIA Kuala Lumpur, 1986; International Exhibition of Art Gallery & Museum Posters, Richmond Art Gallery, Canada, 1987; Malaysian Art 1957-87, National Art Gallery, 1987; UTARA Group Exhibition, Australian High Commission, Kuala Lumpur, 1987.

JOSEPH, TAN (b. 1941)

Born in Alor Star, Kedah 1941. Studied: Sydney University, Australia, 1962; National School of Art, Sydney Australia, 1963-66; Chicago Art Institute, U.S.A., 1970-72, received the Fulbright Hays Scholarship. One-Man Shows: Samat Gallery, Kuala Lumpur, 1968; University of Malaya, 1972. Included in: 'Salon Malaysia' National Art Gallery, 1969; 'Malaysian Art' touring Australia and New Zealand, 1969; 'Poets and Painters' Exhibition, Dewan Bahasa dan Pustaka, Kuala Lumpur, 1970; Group Show, Chicago, 1971; 'Malaysian Art 1956-1973', National Art Gallery, 1973; National Invitation Show, National

Art Gallery, 1973; 'Sydney Biennial', Australia, 1974; 'Malaysian Art since Independence, 1957-1977', National Art Gallery, 1977; '4th Indian Triennale', New Delhi, 1978; 'Malaysian Art 1965-1978', Commonwealth Institute, London, 1978; Contemporary Asian Art Show, Fukuoka Art Museum, Japan, 1980; Premier Show, Malaysian Artists Association, University of Malaya, 1981; 'Geraktara', Penang State Museum, Penang, 1981; 'The Treatment of Local Landscape in Contemporary Malaysian Art Forms 1930-1981' National Art Gallery, 1982; '25 Years of Malaysian Art', National Art Gallery, 1982; ASEAN Mobile Exhibition, 1983; 'Titian 1', National Museum Art Gallery Singapore, 1983; National Invitation Show, National Art Gallery, 1983; 'American Experiences': Malaysian Images, US Embassy, Kuala Lumpur, 1984; Art Exhibition, Saujana Fine Arts, City Hall, Kuala Lumpur, 1984; ASPACAE '85 Exhibition, On-Tai Gallery, 1985; Faculty Show, National Art Gallery, 1985; 2nd Contemporary Asian Art Show, Fukuoka Art Museum, Japan, 1985; 'Space' National Art Gallery, 1986; Seoul Contemporary Asian Art Show, Seoul, Korea, 1986; Faculty Show, National Art Gallery, 1987; Malaysian Art 1957-87, National Art Gallery, 1987.

TONG, TAN (b. 1942)

Born in Kajang, 10th June 1942. Awarded French Government Scholarship for further studies at the Ecole Nationale Superieure des Beaux-Arts Paris, 1964.

One-Man Shows: Foyer des Artistes Gallery, Paris, 1967; Samat Gallery, Kuala Lumpur, 1970; Meyer Gallery, Singapore, 1970; Samat Gallery, Kuala Lumpur, 1976; Beaux-Arts Gallery, Kuala Lumpur, 1982.

Included in Joint Exhibition, Raya Gallery, Melbourne, 1978; 'Titian 1' National Museum Art Gallery Singapore, 1982; Phoenix International Exhibition, Frankfurt, 1982; ICIPA Exhibition, National Museum of History, Taipei, 1982; ICIPA Exhibition, National Museum Art Gallery Singapore, 1983; ICIPA Exhibition, Korea Culture and Arts Foundation Art Centre, Seoul, Korea, 1983; 3-School Professors & Lecturers Joint Exhibition by Chinese Culture University, Taiwan, Nanyang Academy of Fine Arts, Singapore and Malaysian Institute of Art, Malaysia, 1983; National Open Show, National Art Gallery, 1983, 1987; ASPACAE '85 Exhibition, On-Tai Gallery, Kuala Lumpur, 1985; 'SPACE' National Art Gallery, 1986; ASPACAE '87 Exhibition, Ishikawa Prefectural Art Museum, Kanazawa City, Japan, 1987; Malaysian Art 1957-87, National Art Gallery, 1987.

HON YIN, TANG (b. 1943)

Born in Penang, 1943. Self taught artist, studied Geography at the University of Malaya, 1963-67. Included in: National Open Show, National Art Gallery, 1974, 1983-1987; 'Salon Malaysia' National Art Gallery, 1978; 8th

International Festival of the Arts, United World College Singapore, 1978; UTARA Group Exhibition, Penang, 1978-86; UTARA Group Exhibition, National Museum Art Gallery Singapore, 1978; UTARA Group Exhibition, Gallery Wisma Loke Kuala Lumpur, 1980; Premier Show, Malaysian Artists Association, University of Malaya, 1981; 'Titian 1', National Museum Art Gallery Singapore, 1983; '20 Years of Malaysian Art', University of Science Malaysia, 1983; First One-Man Show 'Water-Margin' Galeria, Penang, 1983. Participated in the Invitation Show, Selangor Chinese Town Hall, Kuala Lumpur, 1985; Penang Open Show, Museum and Art Gallery Penang, 1986; Penang Retrospective Art Exhibition, Museum and Art Gallery Penang, 1986. One-Man Show Australian High Commission Kuala Lumpur, 1986; Malaysian Art 1957-87, National Art Gallery, 1987, UTARA Group Exhibition, Australian High Commission, Kuala Lumpur, 1987.

MO-LEONG, TAY (b. 1938)

Born in Penang, 1938. Studied at Provincial Taipeh Normal College, Taiwan, 1957-1960. One-Man Shows: Penang, 1957, 1960; 'Batik Paintings' British Council, Kuala Lumpur, 1965; France-Nell Gallery, Tokyo, 1966; Miami Museum of Modern Art, Florida, U.S.A., 1968; 'Batik Paintings', Adelaide, Australia, 1974. Participated in Group Exhibition, Taipei, 1958; Summer Salon, Art Exhibition, Royal Institute Galleries, London, 1959; Le Salon, Societe des Artistes Francais, Paris, 1960; Sao Paulo Biennale, Brazil, 1969; 'Man & His World', Montreal Canada, 1970; Malaysian Art Touring Australia & New Zealand, 1970; Salon Internationale d'Art, Basle, Switzerland, 1975; 'Bali Series', Penang, 1979; Sculpture Competition for Architecture, Gama Complex, Penang, Awarded the Winners Prize, 1980; 'Treatment of the Local Landscape in Modern Malaysian Art 1930-81' National Art Gallery, 1981; '25 Years of Malaysian Art', National Art Gallery, 1982; Sculpture Competition for E.P.F. Building Mural, awarded Third Prize, 1984; Group Exhibition, U.S.M. Museum & Art Gallery, Penang, 1984; National Open Show, National Art Gallery, 1984, 1985; Saujana Art Exhibition, City Hall, Kuala Lumpur, 1985; Malaysian Art 1957-87, National Art Gallery, 1987; National Open Show, National Art Gallery, 1988.

SYED THAJUDEEN (b. 1943)

Born in Alagan Kulam, Tamil Nadu, India, 1943. Emigrated with family to Penang in 1954. Studied: Pre-University Studies in Humanities at University of Madurai India, 1967-68; Government College of Arts and Crafts Madras, 1968-73. Included in: Government College Annual Shows, Madras India 1970-74; National Open Show, National Art Gallery, Kuala Lumpur, 1974. One-Man Shows: Museum and Gallery Penang, 1975; Samat Art Gallery,

Kuala Lumpur, 1975. Included in: Focus on Young Talents, National Art Gallery, 1977; Open Art and Graphic Prints Show, National Art Gallery, 1977; National Open Show, National Art Gallery, 1979-81, 1983-87; Malaysian Art 1965-78, Commonwealth Institute London, 1978; 'Salon Malaysia', National Art Gallery, 1979; 'Treatment of Landscape in Malaysian Modern Art 1930-81', National Art Gallery, 1982; ASEAN Mobile Exhibition, Kuala Lumpur, Bangkok, Singapore, Manila and Jakarta, 1982; '25 Years of Malaysian Art', National Art Gallery, 1982; 2nd Asian Art Biennale, Dhaka Bangladesh, 1983; Exhibition of Painting and Calligraphy, National Art Gallery, 1984; 12 Malaysian Artists Exhibition, National Museum of History, Taipei, Taiwan, 1985; 2nd Asian Art Show, Fukuoka Art Museum, Fukuoka Japan, 1985; 'Space' National Art Gallery, 1986; Seoul Contemporary Asian Art Show, National Museum of Modern Art, Seoul, Korea, 1986; Malaysian Art 1957-87, National Art Gallery, 1987; National Open Show, National Art Gallery, 1988.

HOY CHEONG, WONG (b. 1960)

Born in Penang, June 5, 1960. Studied: Bradeis University, Waltham, Massachusetts, 1978-1982; Harvard University, Cambridge, Massachusetts, 1982-84; Graduate Department of Art University of Massachusetts, 1984-86. One-Man Shows: 'Recent Paintings and Prints', Wheeler Gallery, Amherst, Massachusetts, 1985; 'In Search of Faraway Places', Herter Gallery I & II, Amherst, Massachusetts, 1986; 'New Works', New York University, New York City, 1986. Included in: Open Studios, Artists' West Association, Boston, Massachusettes, 1985; Travelling American Art Exhibit Centre Colombo Americano in Medellin and Bogota, Colombia, 1986; 67th National Exhibition Museum of Fine Arts, Springfield, Massachusettes, 1986; National Open Show, National Art Gallery, 1987; Malaysian Art 1957-87, National Art Gallery, 1987; 'Young Contemporaries', National Art Gallery, 1987.

JIN LENG, YEOH (b. 1929)

Born in Ipoh, Perak, 1929. Studied: Malayan Teachers' College, Kirkby, United Kingdom, 1952-53; Chelsea School of Art, London, 1957-62; Institute of Education, London University, 1962.

Exhibitions: Group Shows, Arts Council and National Art Gallery, 1963, 1964; One-Man Show, Kuala Lumpur, 1965; 'Grup' — 6 painters at AIA Gallery, Kuala Lumpur; Commonwealth Arts Festival: Travelling Malaysian Art Exhibition, Britain, Germany, Italy, France, 1966/67; 'Salon Malaysia', National Art Gallery, awarded Special Prize, 1968; 'Malaysian Art' Touring Australia and New Zealand, 1968; 5th Tokyo Young Contemporary Biennale 1969, awarded the Japanese Ministry of Foreign Affairs Prize for Painting; 10th Sao Paulo Biennale, Brazil, 1969; 'Poets & Painters'

Exhibition, Dewan Bahasa & Pustaka, Kuala Lumpur, 1970; International Society of Plastic & Audio-Visual Art, Osaka, 1972; Abstract Expressionists of the 60's, National Art Gallery, 1974; United World College Art Exhibition, Singapore, 1976; Indian Triennale, New Delhi, India, 1978; 'Malaysian Art: 1965-78', Commonwealth Institute, London, 1978; ASEAN Mobile Exhibition, 1978, 1985; Singapore Arts Festival, National Museum Art Gallery, Singapore, 1978, 1980; 'Two Malaysian Potters', British Council, 1981; Premier Show, Malaysian Artists Association, University of Malaya, 1981; 'Titian 1', National Museum Art Gallery Singapore, 1982; Invitation Show, National Art Gallery, 1983; National Open Show, National Art Gallery, 1983-85; 2-Man-Show, Australian High Commission, Kuala Lumpur, 1984; 12 Malaysian Artists, Museum of History, Taipei, 1985; ASPACAE '85 Exhibition, On-Tai Gallery, Kuala Lumpur, 1985; Exhibition of Paintings & Photographs Malaysian Heritage Endau/Rompin, National Art Gallery, 1985; Invitation Show, On-Tai Gallery, Kuala Lumpur, 1985; Contemporary Malaysian/British Art, National Art Gallery, 1986; Malaysian Art 1957-87, National Art Gallery, 1987.

AHMAD KHALID YUSOF (b. 1934)

Born in Kuala Lumpur, 1934. Studied: Specialist Teachers Training Institute, 1963, Winchester School of Art, England 1965-69; Ohio State University, U.S.A., 1975-78. One-Man Shows: Samat Gallery Kuala Lumpur, 1970; Hotel Merlin Kuala Lumpur, 1973; Hocking Valley Bank, Ohio, Athens, Ohio, 1977; Ohio State University, 1977; Subway Gallery, Winnipeg, Canada, 1978; International Monetary Fund Gallery, Washington D.C., 1978; The Regent Kuala Lumpur, 1979; Australian High Commission, Kuala Lumpur, 1984; University of Science Malaysia Gallery, 1984; Hotel Equatorial Kuala Lumpur, 1985. Included in: Cheras Art Exhibition, National Art Gallery, 1963; 'Salon Malaysia', National Art Gallery, 1968; '2 Man Art Show' Trafalgar Square, London, 1969; 'Poet, Painters Exhibition', Dewan Bahasa & Pustaka, 1971, 1972; International Society of Plastic & Audio Visual Art Exhibition, Kuala Lumpur, 1972; International Biennial of Prints, Japan, 1972; 'Paper on Paper' Northern Illinois, Chicago, 1977; Malaysian Art 1965-78 Commonwealth Institute, London, 1978; 'Salon Malaysia' National Art Gallery, 1979; Contemporary Asian Art Show, Fukuoka Art Museum, Japan, 1980; Asian Art Exhibition, Bahrain, 1982; National Invitation Show, National Art Gallery, 1983; National Open Show, National Art Gallery, 1983, 1984, 1985, 1986, 1987; 2-Man Show, Bandar Sri Begawan Brunei, 1984; 2nd Asian Art Show, Fukuoka Art Museum, Japan, 1985; 'Space', National Art Gallery, 1986; Contemporary Malaysian/British Art, National Art Gallery, 1986, Faculty Show, National Art Gallery, 1987; Malaysian Art 1957-87, National Art Gallery, 1987.

Bibliography

BOOKS

Sullivan, Michael. *'Chinese Arts in The Twentieth Century'*, Faber & Faber Limited, 1959.

— *'Teng: Batik'*, Yahong Art Gallery, Penang, 1959 (1st. Edition), 1970 (2nd Edition).

— *'Malaysians'*, The Shell Company of the Federation of Malaya Limited, Singapore, 1963.

'Dictionary of International Biography', London, 1968.

Wharton, Dolores. *'Contemporary Artists of Malaysia'*, Asia Society, New York, 1971.

Jacobs, Charles & Babette. *'Chuah Thean Teng'* in Far East Travel Digest, Paul, Richmond & Company (U.S.A.) 1st Edition 1976, 7th. Edition 1984, 8th Edition 1985.

Morais, J. Victor. *'Who's Who in Malaysia 1975-1976 & Guide to Singapore'*, Kuala Lumpur, 1976.

'Dictionary of International Biography' Vol. XIV Cambridge, England, 1977.

'Who's Who in Malaysia, Singapore and Brunei', Vol. 12, 1978.

T.K. Sabapathy. *'Piyadasa'*, Archipelago Publishers, Kuala Lumpur, 1978.

— *'Men of Achievement'*, Vol. 7, International Biographical Centre, Cambridge, England, 1980.

Abdul Ghaffar Ibrahim. *'Dialog Dengan Seniman'* (Dialogue with Artists), Pub. Adabi Sdn Bhd Kuala Lumpur, 1982.

Piyadasa, Redza & T.K. Sabapathy. *'Modern Artists of Malaysia'*, Dewan Bahasa & Pustaka, Kuala Lumpur, 1983.

Siti Zainon Ismail. *'Getaran Jalur & Warna'* (Vibrating Lines & Colours), Pub. Fajar Bakti Company Limited, Petaling Jaya, 1985.

Arney, Sarah. *'Malaysian Batik Creating New Traditions'*, The Malaysian Handicraft Development Corporation, 1987.

JOURNALS/PERIODICALS

— *'Imperial Preference'*, Art, 26 May 1955.

Sullivan, Frank. *'Outstanding Malayan Artist Syed Ahmad Jamal'*, Pelita Vol. 1 No. 3, July/December 1960.

— *'The Flight from Reality — Exhibition of International Contemporary Art'*, The Statesman, 14 February 1961.

S.A. Krishnan, *'Fourth International Contemporary Art Exhibition'*, Roopa Lekha, New Delhi, Vol. XXXII No. 1, July 1961, pp. 41-52.

— *'Young Commonwealth Artists on Show in London'*, Journal of the British Association of Malaya, London, April 14, 1962.

Watkinson, Ray. *'Summer Exhibition'*, The Arts Review (London), Summer Edition, May 18 — June 1, 1963.

Kim Siew. *'Chuah Thean Teng — Batik Master'*, New Times 1964 Issue No. 22, Malaysian New Times Publishing Co.

Mc Calum, Beryl. *'Royal Academy Schools Exhibition'*, The Arts Review (London) November 14-28, 1964.

Blakeston, Oswell. *'Ibrahim Hussein — John Whibley Gallery'*, The Arts Review (London), November 16-30, 1964.

Ismail Mustam. *'Malaysia Bukan Mexico'* (Malaysia is not Mexico), Dewan Masyarakat, November 1964, pp. 17-20.

Sullivan, Frank. *'Thoughts of an Art Collector'*, The Strait Times Annual 1965, Strait Times Publications.

Syed Ahmad Jamal. *'A Private Art Collection in Malaysia'*, Hemisphere, Vol. 9 No. 7 (Sydney Australia), July 1965.

Dempsey, Andrew. *'Commonwealth Festival of Arts/Glasgow'*, The Arts Review, October 1965.

Sullivan, Frank. *'Batik Art'*, The Strait Times Annual 1966, Strait Times Publications.

Mc Callum, Beryl. *'Malaysian Art'*, The Arts Review, February 1966.

— *'Teng-Batik Artist'*, Free World, January 1967, Vol. XV No. 12, Free Asia Press (Philippines).

— *'Violent Movement'*, Newsweek, January 5, 1968.

Dawn Zain. *'The Malaysian Abstract Art Scene Today'*, Pelita, Vol. 6 No. 4, 1968 pp. 9-14, An Esso Publication.

Slusser, Jean P. *'This Show Devoted to 25 Oils '*, The Ann Arbor News, March 2, 1969.

— *'Syed Ahmad Jamal — Abstract From Cheras'*, Tenggara 4, April 1969, pp. 28-35.

Trois, Gustav. *'Art & Artists '*, Chevy Chase Tribune, May 16, 1969.

Hall, Carolyn. *'Galleries Tentalize with New Exhibits '*, The Eccentric, September 11, 1969.

— *'Malaysian Artist Ibrahim Hussein'*, Mirror (Manila) September 13, 1969.

— *'Interview De S. Ahmad Jamal — Peindre sa Foi En L'Hummanite'*, Way Forum (Paris) No. 74, October 1969, pp. 5-8.

— *'Artist Ibrahim Hussein and his rolling moments'*, Fanfare, January 1970.

Harda, Jane. *'The Arts '*, Washington Post, March 1970.

Dawn Zain. *'An Appreciation of Ibrahim Hussein'*, Pelita 1st. quarter 1970, p. 10.

Kemala. *'Syed Ahmad Jamal yang abstraksionistis'*, Dewan Satera, May 1971, p. 3.

Steinle, Peggy. *'Images From a Fast-Moving Train'*, Insight (Hong Kong) January 1972.

Dawn Zain. *'An Appreciation of Dzulkifli Buyong'*, Pelita, Vol. 10 No. 4 1972, pp. 10-14.

Phillips, Anne. *'Artist Chuah Thean Teng: Brilliant Batik Paintings by Noted Artist'*, Palm Spring Life, November 1972 Vol. XV No. 3, Dessert Publication Inc. (U.S.A.).

— *'Seven Malaysian Artists'*, Art International Vol. XVI/5 March 1972.

Steinle, Peggy. *'Artists of Asia'*, The Asia Magazine, June 18, 1973.

Ismail Zain. *'Beberapa Unsur Pengutaraan Abdul Latiff'*, Dewan Sastera, July 1973, pp. 26-29.

Manaf Abdullah. *'Ibrahim Hussein: Satu Penghargaan'*, Dewan Sastera, August 1973, pp. 2-3.

Manaf Abdullah. *'Portrait of an artist Ibrahim Hussein'*, Malaysian Panorama, Vol. 4, No. 2, 1974, p. 20.

Piyadasa, Redza. *'ASEAN's artists are more individualistic, more involved, more international'*, Strait Times Annual 1975, p. 105.

— *'An Asian Rainbow'*, Asia Week, June 25, 1976, p. 18-23.

Siti Zainon Ismail. *'Langkawi: Lewat Imaginasi dan Realiti Latiff'*, Dewan Sastera, January 1977, pp. 6-8.

Syed Ahmad Jamal. *'Senirupa di Malaysia 1957-77: Satu Renungan'*, Dewan Sastera, October 1977, pp. 50-52.

Brooke, Marcus. *'Batik Modernisms by Teng of Penang'*, Orientations, November 1977 Vol. 8 No. 11, Pacific Magazines Ltd. (Hong Kong).

Thean Yang, Lim. *'Teng's Batik Painting'*, Artist Third Issue, August 1978, Artist Publications (Hong Kong).

Chew Teng Beng. *'Art Education in Malaysian Schools: Problems and Remedies.'* Paper presented at the International Society for Education Through Art 23rd INSEA World Congress, Adelaide: S.A., 12-19 August 1978.

Phillpotts, Beatrice. *'Malaysian Art 1965-78'*, Arts Review, (London) Vol. XXX No. 22 November 1978, p. 622.

Syed Ahmad Jamal. *'Contemporary Malaysian Art'*, New Strait Times Annual 1979, pp. 71-78.

Syed Ahmad Jamal. *'Development of Contemporary Malaysian Art'*, Malaysian Historical Association Kuala Lumpur 1979.

Syed Ahmad Jamal. *'Business and the Arts'*, Esso Collection, Kuala Lumpur, 1979.

Zakaria Ali. *'Arca Dinding Disebalik Tandatanya'*, Dewan Budaya, April 1979, pp. 28-29.

Piyadasa, Redza. *'Pelukis Moden Malaysia Syed Ahmad Jamal'*, Dewan Budaya, August 1979, pp. 55-57.

T.K. Sabapathy. *'Pelukis Moden Malaysia Chuah Thean Teng'*, Dewan Budaya, November 1979.

Sharifah Fatimah Zubir. *'Ruang Dalaman Dalam Lukisan'*, Dewan Budaya, February 1979, pp. 40-43.

Syed Ahmad Jamal. *'Seni Lukis Malaysia 1978 — Tak Jemu meneroka tak lesu Berkarya'*, Dewan Budaya, March 1979, pp. 40-43.

T.K. Sabapathy. *'Pelukis Moden Malaysia Mohd Hoessein Enas'*, Dewan Budaya, July 1979, pp. 55-57.

Marina Samad. *'Esso Art Collection: An Interview with Mrs Margaret Kruizenga'*, Pelita Vol. 3 1980, p. 14.

— *'Establishing the Genuine Malay'*, Asia Week, (Hong Kong), January 1980.

Piyadasa, Redza. *'Pelukis Moden Malaysia Abdul Latiff Mohidin'*, Dewan Budaya, January 1980.

T.K. Sabapathy. *'Pelukis Moden Malaysia Cheong Laitong'*, Dewan Budaya, March 1980.

T.K. Sabapathy. *'Pelukis Moden Malaysia Ibrahim Hussein'*, Dewan Budaya, May 1980.

April Hersey. *'Asian Summer School'*, Craft Australia 84 (Summer 1980), pp. 31-33.

Syed Ahmad Jamal. *'Arabic Calligraphy in Malaysia'*, Orientations, Vol. 11 No. 8 August 1980.

Piyadasa, Redza. *'Pelukis Moden Malaysia Khoo Sui-Ho'*, Dewan Budaya, September 1980.

T.K. Sabapathy. *'UTARA 80 Remarks on Group Exhibitions'*, Dewan Budaya, October 1980.

Piyadasa, Redza. *'Pelukis Moden Malaysia Ismail Zain'*, Dewan Budaya, October 1980.

Piyadasa, Redza. *'Pelukis Moden Malaysia Zulkifli Dahalan'*, Dewan Budaya, November 1980.

Dorine A Arrasjid. *'Paper Casting'*, School Arts 80 (December 1980), pp. 31-33.

Syed Ahmad Jamal. *'Seni Rupa dan Seni Bina'* (Art and Architecture) Majallah Akitek, Vol. 1 March 1981, pp. 33-36.

Piyadasa, Redza. *'Pelukis Moden Malaysia Sulaiman Esa'*, Dewan Budaya, March 1981, pp. 55-57.

Siti Zainon Ismail. *'Khalil Ibrahim'*, Dewan Budaya, April 1981, pp. 55-56.

Siti Zainon Ismail. *'Ahmad Khalid Yusof'*, Dewan Budaya, May 1981, pp. 55-56.

Siti Zainon Ismail. *'Sharifah Fatimah Zubir'*, Dewan Budaya, July 1981, pp. 55-57.

Siti Zainon Ismail. *'Lee Kian Seng'*, Dewan Budaya, November 1981, pp. 55-57.

Alina Ranee. *'The House as Portrait of the Artist'*, Her World Annual 1982, pp. 120-123.

Siti Zainon Ismail. *'Fauzan Omar'*, Dewan Budaya, May 1982, pp. 55-57.

Chin Chee, Neoh. *'Batik Painting As An Art'*, Selnews July 1982 Vol. 1 No. 2, Selangor Pewter Co. Sdn Bhd.

Siti Zainon Ismail. *'Chung Chen Sun'*, Dewan Budaya, August 1982, pp. 55-57.

Syed Ahmad Jamal. *'Seni Khat di Malaysia'*, Dewan Budaya, September 1982.

Siti Zainon Ismail. *'Syed Shaharuddin Bakeri'*, Dewan Budaya, October 1982, pp. 55-58.

Wilkinson, Julia. *'The Master of Batik Painting'*, The Asia Magazine, October 1982.

Raja Zahabuddin Yaacob. *'Sesuku Abad Ia Mencari Wajah'*, Dewan Budaya, December 1982, pp. 40-43.

T.K. Sabapathy. *'Premises for Critical Studies of Modern Art in Southeast Asia'*, Architecture Journal School of Architecture, National University of Singapore 1983, pp. 1-6.

A. Guillermo. *'Piyadasa on Art'*, Observer Magazine (Manila), January 1983.

Syed Adam Aljafri. *'Voices of Silence'*, The New Strait Times Annual 1983, pp. 132-140.

C.S. Pixie. *'Whither Culture? Art and Latiff'*, The New Strait Times Annual 1983, pp. 117-121.

Eriksen, Erik. *'Painting from Malaysia'*, KEAC Bladet, April 1983, p. 16.

Armentrout, Fred. *'Penang's Northern Lights'*, Pacific Magazine, April-June 1983, pp. 38-39.

— *'Gallery Round-up'*, The Bulletin (Brussels), October 1983.

Syed Ahmad Jamal. *'Modern Artists of Malaysia'*, Dewan Budaya, November 1983, pp. 42-45.

Turin, David. *'For Arts Sake'*, Justice, November 1983, p. 6.

Siti Zainon Ismail. *'Pameran Cat Air Malaysia'*, Dewan Budaya, January 1984, pp. 46-49.

Dzulhaimi Md. Zain. *'Batik dalam Seni Lukis Moden Malaysia'*, Dewan Budaya, March 1984, pp. 46-48.

T.K. Sabapathy. *'Pameran dan Simposium Seni Lukis ASEAN'*, Dewan Budaya, April 1984.

Chu-Li. *'Print-Maker'* — Eyebrow Raiser Long Thien Shih, New Straits Times Annual, 1984, pp. 137-144.

Chu-Li. *'Daripada Cinta dan Kebenaran Aza Mencipta Nazak'*, Dewan Budaya, May 1984, pp. 24-27.

Chu-Li. *'Kearah Konsep Pemasaran Karya Seni'*, Dewan Budaya, November 1984, pp. 51-55.

Chu-Li. *'Profile: Sharifah Fatimah Zubir'*, Arts and The Islamic World, Vol. 2 No. 3 Autumn 1984, pp. 44-48.

Chu-Li. *'Three Artists With An Islamic Idiom'*, The New Strait Times Annual 1985, pp. 62-69.

Chui Lin, Chow. *'A Foray Into Fine Art'*, Female Annual 1985, pp. 178-181.

Olsen, Bob. *'The Paintings of Cultural Estrangement'*, Circuit, February 1985, p. 16.

Dzulhaimi Md Zain. *'Art Does Not Function in A Vacuum'*, Dewan Budaya, February 1985, pp. 52-55.

Peng Khuan, Fong. *'Toya'*, Wings of Gold Vol. 11 No. 5, May 1985, pp. 34-39.

Aron. *'Ibrahim Hussein: Man Behind the Canvases'*, Male View, October/November 1985, pp. 34-37.

Raja Zahabuddin Yaacob. *'Bukankah Seni Untuk Masyarakat'*, Dewan Budaya, November 1985, pp. 53-57.

Chew Teng Beng. *'Papermaking from Selected Malaysian Fibers'* in Marilyn Zurmuehlen, ed. Working Papers in Art Education. Iowa City, Iowa: The University of Iowa, 1985.

— *'Ninth National Art Exhibition'*, National Art Gallery Kuala Lumpur, 1966.

— *'Group Exhibition'*, Balai Ampang Kuala Lumpur, 1967.

— *'Chuah Thean Teng'*, Stichting Twents-Gelders Textielmuseum, Enschede, Holland, 1967.

— *'Tenth National Art Exhibition'*, National Art Gallery Kuala Lumpur, 1967.

— *'First Solo Exhibition '*, Samat Art Gallery, Kuala Lumpur, 1967. Text by Syed Ahmad Jamal.

— *'Paintings by Teng Beng Chew '*, Rubiner Gallery, Royal Oak, Michigan, April 2 through April 26, 1968.

— *'Mainstreams 1968 '*, The Grover M. Hermann Fine Arts Center, Marietta, Ohio, May 5 through June 9, 1968.

— *' The Fourth Bucknell Annual National Drawing Exhibition 1968 '*, The Ellen Clarke Bertrand Library Art Galleries, Lewisburg, Pennsylvania, April 14 through May 2, 1968.

— *'Michigan Painting 1968 '*, The Bloomfield Art Association Gallery, Bloomfield Hills, Michigan, February 11 through March 17, 1968.

— *'Ibrahim Hussein'*, Newsweek Gallery, New York, 1968.

— *'Contemporary World Art Triennale New Delhi'*, Lalit Kala Akademi, 1968.

— *'Eleventh National Art Exhibition'*, National Art Gallery Kuala Lumpur, 1968.

— *'Sao Paolo X Biennale'*, Secretariat of Education & Culture, Brazil, 1969.

— *' Paintings by Chew Teng Beng '*, Forsythe Gallery, Ann Arbor, Michigan, February 23 through March 13, 1969.

— *' Young Artists Around the World '*, Union Carbide Building, New York City, New York, May 1969.

— *' 7th Annual Drawing of Prize '*, International Monetary Fund Building, Washington D.C., Organized by the Art Society of the International Monetary Fund, June 1969.

— *'Paintings and Prints of Chew Teng Beng '*, Little Gallery, Birmingham, Michigan, 1969.

— *Paintings and Prints by Chew Teng Beng '*, Georgetown Gallery, Washington D.C., May 1969.

— *' Chew Teng Beng '*, International Monetary Fund Building, Washington D.C., March 1970.

— *'American Workshop'*, Roma, Milano, Napoli, Italy, 1970.

— *'Choong Kam Kow'*, Dewan Bahasa & Pustaka Kuala Lumpur, 1970.

— *'Malaysian Art 1932-1971'*, National Art Gallery Kuala Lumpur, 1971.

— *'Personal Choice'*, National Art Gallery Kuala Lumpur, 1971.

Denson, Alan. *'Visual Taste'*, Catalogue of an author's art collection, Kendal 1971.

— *'Chew Teng Beng'*, Goshen College Art Gallery, Goshen, Indiana, February 1971.

— *'Chew Teng Beng — Paintings, Prints'*, Forsythe Gallery, Ann Arbor, Michigan, April 1972.

— *'Chew Teng Beng'*, University of Science Malaysia Museum and Gallery, Penang, October 1972.

— *'Chuah Thean Teng'*, The Gallery, Palm Springs, U.S.A., 1972.

— *'Chuah Thean Teng'*, Rinera Galleries and Argyle Art Centre, New South Wales, Australia, 1972.

— *'Malaysian Landscape Exhibition'*, National Art Gallery Kuala Lumpur, 1972.

— *'Sharifah Fatimah Zubir Exhibition of Paintings'*, Alpha Gallery Singapore, 1972.

— *'Annual Invitation Show'*, National Art Gallery Kuala Lumpur, 1972.

— *'9th Annual Penang Art Gallery Exhibition'*, Penang State Museum and Art Gallery, Penang, 1973. Forword by Chew Teng Beng.

— *'19th Annual Penang Arts Council Exhibition'*, Penang State Museum and Art Gallery, Penang, September 1973. Forword by Chew Teng Beng.

— *'Retrospective Abdul Latiff Mohidin'*, National Art Gallery Kuala Lumpur, 1973.

— *'Annual Invitation Show'*, National Art Gallery Kuala Lumpur, 1973.

— *'A Critical Assessment of the Malaysian Expressionist Commitment of the Sixties'*, National Art Gallery Kuala Lumpur, 1974.

— *'International Art Exhibition'*, Basel, Switzerland, 1974.

— *'Internationaler Markt Fur Aktuelle Kunst'*, Dusseldorf, West Germany, 1974.

— *'Towards A Mystical Reality'*, A Documentation of Jointly Initiated Experiences By Redza Piyadasa and Sulaiman Haji Esa, Kuala Lumpur, 1974.

— *'Retrospective Syed Ahmad Jamal'*, National Art Gallery Kuala Lumpur, 1975.

Willets, William. *'Ibrahim Hussein'*, University of Malaya, 1975.

— *'Chuah Thean Teng'*, Freemantle Art Centre, Perth Australia, 1975.

— *'International Art Exhibition'*, Basel, Switzerland, 1975.

— *'Chung Chen Sun Art Exhibition for Malaysian Institute of Art Building Fund'*, Kuala Lumpur, 1975.

T.K. Sabapathy. *'A View of Modern Sculpture in Malaysia'*, National Art Gallery Kuala Lumpur, 1976.

— *'Pameran Arca Dinding Latiff Mohidin'*, Dewan Tunku Cansellor University of Malaya Kuala Lumpur, 1976.

— *'Paintings by Contemporary Artists of Malaysia, Singapore and Indonesia from the Collection of Lim Chong Keat'*, Penang State Museum & Gallery, 1976.

— *'Malaysian Art 1957-1977'*, National Art Gallery Kuala Lumpur, 1977.

— *'Fourth Triennale India'*, Lalit Kala Akademi, New Delhi, 1978.

— *'In Memory of Zulkifli Mohd Dahalan'*, Lincoln Centre Kuala Lumpur, 1978.

— *'Sharifah Fatimah Solo Exhibition'*, Penang Museum, 1978.

Chew Teng Beng. *'Handmade Papers as a Creative Medium.'* Museum and Gallery University of Science Malaysia, 1978.

Syed Ahmad Jamal. *'Malaysian Art 1965-78'*, Commonwealth Institute London, 1978.

— *'The Art Exhibition of the Tenth Anniversary of University Science of Malaysia'*, Museum and Gallery U.S.M. Penang, 1979.

— *'Salon Malaysia'*, National Art Gallery Kuala Lumpur, 1979.

T.K. Sabapathy. *'Utara 80: Remarks on Group Exhibitions'*, An Exhibition of Paintings by 8 North Malaysian Artists, Kuala Lumpur, 1980.

— *'Festival: Contemporary Asian Art Show 1980'*, Fukuoka Art Museum, Japan, 1980.

Florina H. Capistrano. *'Chew Teng Beng: Handmade Paper as Art.'* East & West Art, Victoria, Australia, 1980.

Piyadasa, Redza. *'The Treatment of the Local Landscape in Modern Malaysian Art, 1930-1981'*, National Art Gallery Kuala Lumpur, 1981.

— *'ASEAN Exhibition of Painting, Graphic Arts and Photography'*, National Gallery Bangkok, 1981.

Zakaria Ali. *'Art and Artist: The Malaysian Experience'*, Inaugural Exhibition Malaysian Artists' Association, Kuala Lumpur, 1981.

— *'The First Exhibition of Asian Art'*, Arab Asian Bank Bahrain, 1981.

— *'Chuah Thean Teng'*, Georgetown Gallery, British Columbia, Canada, 1981.

Piyadasa, Redza. *'The Art of Nirmala Shanmughalingam'*, Kuala Lumpur, 1981.

— *'Utara 81'* Exhibition of Paintings, Penang, 1981.

— *'Fifth Triennale India'*, Lalit Kala Akademi New Delhi, 1982.

Syed Ahmad Jamal. *'25 Years of Malaysian Art'*, National Art Gallery Kuala Lumpur, 1982.

Siti Zainon Ismail. *'Sericipta Puteri Malaysia'*, Kuala Lumpur, 1982.

— *'Exhibition of Painting, Sculpture, Graphic and Handicraft from Private Collection'*, National Art Gallery Kuala Lumpur, 1982.

— *'Geraktara'*, Penang State Museum, 1982.

— *'International Contemporary Ink Painting Association Inaugural Exhibition'*, National Museum of History Taipei, Taiwan, 1982.

Piyadasa, Redza. *'The Treatment of the Local Landscape in Contemporary Malaysian Art Forms'*, ASEAN Exhibition of Paintings and Photographs, National Art Gallery Kuala Lumpur, 1982, pp. 50-53.

Animah Syed Mohammad. *'......Sometime I am the silence — Wind, Water and Fire'* Exhibition of Paintings by Annuar Rashid, Kuala Lumpur, 1983.

Chu-Li. *'Nursiyah and Other Images'*, Exhibition of Paintings by Sharifah Fatimah Zubir, Kuala Lumpur, 1983.

— *'Latiff Mohidin Mindscape '83'*, Kuala Lumpur, 1983.

— *'National Open Art Exhibition'*, National Art Gallery Kuala Lumpur, 1983.

— *'The Question of Palestine'*, Department of Information Kuala Lumpur, 1983.

— *'International Contemporary Ink Painting Association Exhibition'*, Kuala Lumpur, 1983.

— *'National Art Gallery 1958-1983'*, National Art Gallery Kuala Lumpur, 1983.

— *'National Invitation Exhibition'*, National Art Gallery Kuala Lumpur, 1983.

— *'Titian 1'* Art Exhibition by Malaysian Artists' Association at National Museum Art Gallery Singapore, 1983.

— *'Malaysian Watercolour Society's First Annual Exhibition'*, Kuala Lumpur, 1983.

Syed Ahmad Jamal. *'Seni Rupa Islam'*, National Art Gallery Kuala Lumpur, 1984.

Jin Leng, Yeoh. *'American Experiences: Malaysian Images — A Review'*, American Embassy Kuala Lumpur, 1984.

— *'Exhibition of Paintings, Prints & Drawings by Ahmad Khalid Yusof and Sharifah Fatimah Zubir'*, Bandar Seri Begawan, 1984.

— *'Nazak — the Crucial Moment by Aza Osman'*, A.P. Gallery Kuala Lumpur, 1984.

— *'Malaysian Watercolour Society's Second Annual Exhibition'*, Kuala Lumpur, 1984.

— *'Towards Unity'*, Recent works by Sulaiman Haji Esa, texts by Dr Mohd Ahmad Haji Hashim and Animah Syed Mohamed, Kuala Lumpur, 1984.

— *'Saujana Fine Arts'*, Kuala Lumpur, 1984.

— *'3rd ASEAN Exhibition of Painting and Photograph'*, Manila, 1984.

R. Chelliah. *'Ismail Abdul Latiff'*, Kuala Lumpur, 1984.

Eng Hooi, Lim. *'Notes on Common Features in Some Works of Utara'*, Exhibition of Paintings Utara '84, Museum & Gallery University Science Malaysia, Penang. (Reprinted in Utara '85 Kuala Lumpur).

— *'Exhibition of Paintings and Photographs Malaysian Heritage Endau-Rompin'*, National Art Gallery Kuala Lumpur, 1985.

— *'National Open Exhibition'*, National Art Gallery Kuala Lumpur, 1985.

— *'Faculty Show'*, National Art Gallery Kuala Lumpur, 1985.

— *'12 Malaysian Artists Exhibition in Taipei'*, National Museum of History, Taipei, Taiwan, 1985.

— *'ASPACAE '85 Art Exhibition'*, Galeri On-Tai Kuala Lumpur, 1985.

— 'Rupa '85: International Contemporary Ink-Painting Association Exhibition', Malaysia, 1985.

— 'Fabric Art', National Art Gallery Kuala Lumpur, 1985.

Syed Ahmad Jamal. 'The Present Condition of Contemporary Art in Malaysia', 2nd Asian Art Show, Fukuoka Art Museum, Japan, pp. 118-120.

Syed Ahmad Jamal. 'Current Approaches in Art in the ASEAN Region — Malaysia', 4th. ASEAN Exhibition of Painting and Photography, National Museum Art Gallery Singapore, 1985.

Chu-Li. 'Evolution and Transition — Ahmad Khalid Yusof', Kuala Lumpur, 1985.

— 'National Open Art Exhibition', National Art Gallery Kuala Lumpur, 1986.

— 'Ibrahim Hussein: A Retrospective', Texts by Chu-Li, T.K. Sabapathy, Fred Armentrout, Mochtar Lubis, Hijjas Kasturi, Datuk Lim Chong Keat and Tan Sri Muhammad Ghazali Shafie, National Art Gallery Kuala Lumpur, 1986.

— 'Side By Side: Exhibition of Contemporary British and Malaysian Art', National Art Gallery Kuala Lumpur, 1986.

— 'Malaysian Watercolour Society's Fourth Annual Exhibition', Kuala Lumpur, 1986.

— 'Asian Contemporary Art Exhibition', Singapore Festival of Arts, National Museum Art Gallery Singapore, 1986.

Chu-Li. 'Paintings: A Way of Seeing', Exhibition of Paintings by Tang Hon Yin, Kuala Lumpur, 1986.

Syed Ahmad Jamal. 'Space', National Art Gallery Kuala Lumpur, 1986.

Syed Ahmad Jamal. 'The Present Condition of Contemporary Art I Malaysia', Seoul Contemporary Asian Art Show, The National Museum of Modern Art, Seoul, Korea, 1986, pp. 297-301.

— 'National Open Art Exhibition', National Art Gallery Kuala Lumpur, 1987.

— 'Faculty Show', National Art Gallery Kuala Lumpur, 1987.

Chaoyu, Huang Jackie. 'Colour — Rhythm and Rhyme in Nature', Paintings by Sharifah Fatimah Zubir, Galeri Citra, Kuala Lumpur, 1987.

Syed Ahmad Jamal. 'Malaysian Art 1957-87', National Art Gallery, Kuala Lumpur, 1987.

— 'Digital Collage', One-man Art Exhibition by Ismail Zain, Texts by Redza Piyadasa, T.K. Sabapathy and Noordin Hassan, Galeri Citra, Kuala Lumpur, 1988.

Syed Ahmad Jamal. *'Endau/Rompin Mengabadikan Pengalaman'*, Dewan Budaya, January 1986, pp. 54-55.

Ahmad Khalid Yusof. *'Seni Lukis Asia: Pandangan Dari Lingkungan Asia 1'*, Dewan Budaya, February 1986, pp. 53-55.

— *'Jovenes pintores estadouni denses'*, Magazine Dominical, Columbia, April 1986, pp. 16-17.

Spiljevic, Dragana. *'Exhibition at the Non-Aligned Summit'*, Yugoslav Review 9-10, 1986, pp. 40-44.

Ali Atan. *'Tang Hon Yin: Incidental Artist'*, Visage (Malaysia), Vol. 11 No. 4 August 1986, pp. 46-51.

— *'Drawing Inspiration Directly From The Past'*, Artspeak, New York City, September 1986, p. 7.

Dinsman. *'Karya Nirmala: Digantung, Diturunkan, Digantung'*, Dewan Budaya, November 1986.

Chew Teng Beng. *' The Tradition of Papermaking and the Paper Arts: A Proposal for Economic Development in Malaysia.'* Paper presented at Advancing Living Traditions in Arts as Cultural Renewal: One Response to Industrial Crises and Problems of Third World Economic Development. New York City, N.Y., 18 November, 1986.

Raja Zahabuddin Yaacob. *'Choong Kam Kow: Seni adalah Cara Hidup'*, Dewan Budaya, February 1987, pp. 53-55.

Raja Zahabuddin Yaacob. *'Nirmala Seniman Foto-Konseptualis'*, Dewan Budaya, April 1987, pp. 53-55.

Piyadasa, Redza. *'Seni Lukis Moden DiAsia'*, Dewan Budaya, May 1987, pp. 52-55.

Chew Teng Beng. *'Papermaking from Selected Malaysian Fibers: An Investigation of its Artistic Potential Through Creation of Original Paper Artworks.* Ph.D. dissertation, New York University, 1987.

EXHIBITION CATALOGUES

— *'Chuah Thean Teng'*, Arts Council, Penang, 1955.

— *'Chuah Thean Teng'*, Singapore Arts Society, 1956.

— *'Chuah Thean Teng'*, Arts Council Kuala Lumpur, 1957.

— *'First National Loan Exhibition'*, National Art Gallery Kuala Lumpur, 1958.

— *'Chuah Thean Teng'*, Commonwealth Institute London, 1959.

— *'Third National Art Exhibition'*, National Art Gallery Kuala Lumpur, 1960.

— *'Fourth National Art Exhibition'*, National Art Gallery Kuala Lumpur, 1961.

— *'Exhibition of Paintings by Syed Ahmad Jamal'*, Singapore Art Society, 1961.

— *'International Art Exhibition'*, Saigon. An International Exposition by artists of Vietnam and Friendly Countries, 1962.

— *'Fifth National Art Exhibition'*, National Art Gallery Kuala Lumpur, 1962.

— *'Chuah Thean Teng'*, Arts Council Kuala Lumpur, 1963.

— *'Sixth National Art Exhibition'*, National Art Gallery Kuala Lumpur, 1963.

— *'Chuah Thean Teng'*, Pomeroy Galleries, San Francisco, U.S.A., 1964.

— *'Seventh National Art Exhibition'*, National Art Gallery Kuala Lumpur, 1964.

— *'Chuah Thean Teng'*, National Art Gallery Kuala Lumpur, 1965.

— *'Ibrahim Hussein Solo Exhibition'*, Gallerie Internationale, New York., 1965.

— *'Chuah Thean Teng'*, Commonwealth Institute London, 1965.

— *'Chuah Thean Teng'*, Municipal Gallery of Fine Art, Dublin, Ireland, 1965.

— *'Chuah Thean Teng'*, Arts Council, Kilkenny Castle, United Kingdom, 1965.

— *'The Paintings of the Chew Brothers'*, Arts Council Kuala Lumpur, August 9 through August 14 1965.
Text by Syed Ahmad Jamal.

— *'The Paintings of the Chew Brothers'*, Centre 65, Singapore, September 25 through October 3, 1965.
Text by Lim Chong Keat.

— *'Chuah Thean Teng'*, Arts Council, Cork, United Kingdom, 1965.

— *'Exhibition of Malaysian Art for the Commonwealth Arts Festival'*, National Art Gallery Kuala Lumpur, 1965.

— *'The Sullivan Art Collection'*, National Art Gallery Kuala Lumpur, 1965.

— *'First One-Man Show of Paintings by Hoessein'*, National Art Gallery, 1966.

— *'Chuah Thean Teng'*, Lower Gallery, London, 1966.

— *'Ibrahim Hussein Solo Exhibition'*, Chinese Chamber of Commerce Singapore, 1966.